Bruegel

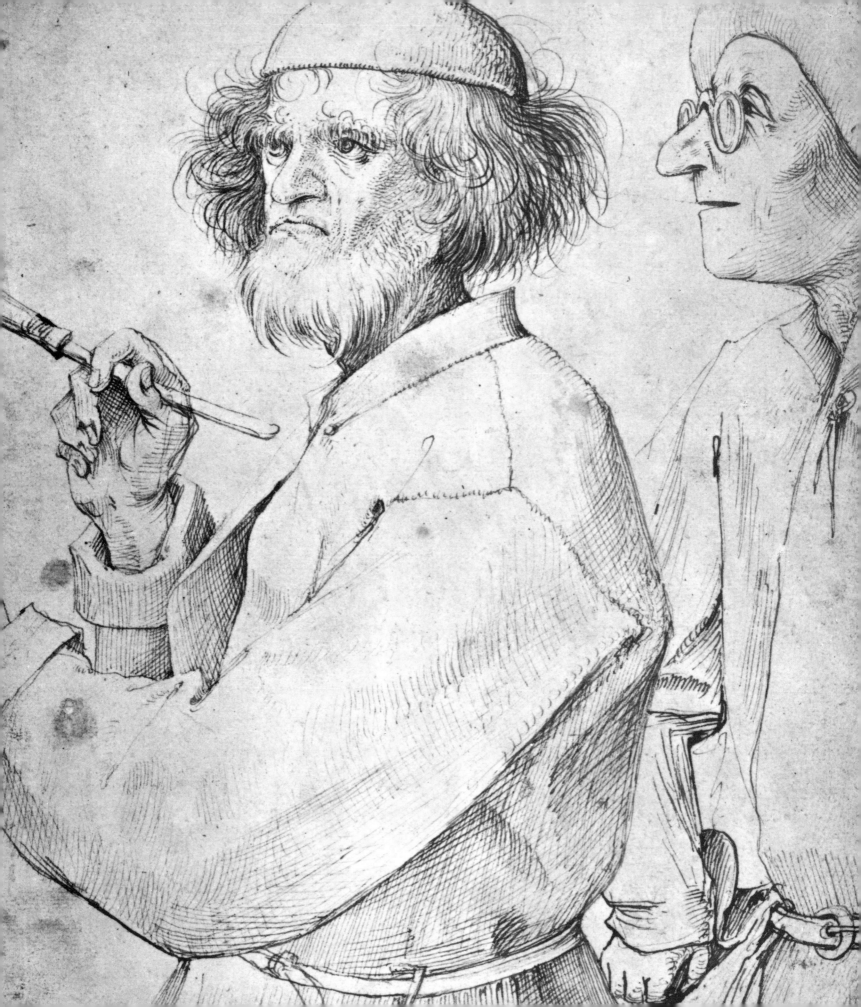

Marguerite Kay

Bruegel

The Colour Library of Art

Hamlyn

London · New York · Sydney · Toronto

Acknowledgments

The following painting is reproduced by Gracious Permission of Her Majesty the Queen: (Plate 20). The other works in this volume are reproduced by kind permission of the following collections, galleries and museums to which they belong: Alte Pinakothek, Munich (Plates 36, 41, 42); British Museum, London (Figure 6); Cathedral of St Bavo, Ghent (Figure 13); Darmstadt Landsmuseum (Plate 25); Dr F. Delporte, Brussels (Plate 19); Courtesy of the Detroit Institute of Art (Plate 38); Galleria Doria Pamphili, Rome (Plate 4); Gemäldegalerie, Staatliche Museen, Berlin-Dahlem (Plate 26, Figure 11); Graphische Sammlung Albertina, Vienna (Frontispiece, Figures 1 and 2); Hamburger Kunsthalle (Figure 9); Kunsthistorisches Museum, Vienna (Plates 5, 6, 7, 8, 9, 15, 16, 17, 18, 23, 24, 27, 28, 29, 30, 31, 32, 39, 40, 49, 51, Figures 5 and 10); Metropolitan Museum, The Rogers Fund 1919, New York (Plates 13, 14, 43); Musée Meyer Van den Bergh, Antwerp (Plates 34, 35); Musées Royaux des Beaux-Arts, Brussels (Plates 2, 21, 22); Musée Condé, Chantilly (Figure 7); Musée National du Louvre, Paris (Plate 47); Musei e Gallerie Nazionali, Naples (Plates 44, 45, 46, 48); Museo Nacional del Prado, Madrid (Plates 32, 33, Figure 9); Narodni Gallery, Prague (Plates 10, 11, 12); National Gallery, London (Plate 37); Private Collection (Plate 1); Putnam Foundation, Timken Art Gallery, San Diego (Plate 3); Dr Count Antoine Seilern (Figure 12).

The following photographs were supplied by:
A.C.L., Brussels (Figure 13); Alinari, Florence (Figure 5); Pasquale de Antonis, Rome (Plate 4); Joachim Blauel, Munich (Plates 37, 42); British Museum, London (Figure 6); Darmstadt Landsmuseum (Plate 25); Giraudon, Paris (Figure 7); Graphische Sammlung Albertina, Vienna (Frontispiece, Figures 1, 2) Michael Holford (figure 13); Ralph Kleinhempel, Hamburg (Figure 8); Joseph Klima Jnr. (Plate 38); Kunsthistorisches Museum, Vienna (Figures 5 and 10); Louis Loose, Brussels (Plates 2, 19, 21, 34); MAS, Barcelona (Plate 32); Metropolitan Museum of Art, New York (Plate 13); Erwin Meyer, Vienna (Plates 5, 6, 8, 15, 17, 24, 28, 30, 32, 40, 41, 49, 51); Narodni Gallery, Prague (Plate 10); National Gallery, London (Plate 37); Scala, Florence (Plates 44, 48); Service de Documentation, Versailles (Plate 48); Staatliche Museen, Berlin-Dahlem (Plate 26); Walter Steinkopf (Figure 11); John F. Waggaman, La Jolla, California (Plate 3); Mansell-Anderson, London (Figure 9); Paul Hamlyn Archives (Figure 3).

Published by
THE HAMLYN PUBLISHING GROUP LIMITED
London · New York · Sydney · Toronto
Hamlyn House, Feltham, Middlesex, England

© copyright The Hamlyn Publishing Group Limited 1969
Reprinted 1971

ISBN 0 600 03801 7

Printed in Italy by Officine Grafiche Arnoldo Mondadori, Verona

Frontispiece: *The Painter and the Connoisseur. c. 1565.*

Introduction Page 6
Selected book list 26
Notes on the illustrations 27

THE BLACK AND WHITE ILLUSTRATIONS

 1 The Painter and the Connoisseur Frontispiece
 2 Big Fish eat little Fish 9
 3 Martin Schongauer: Peasant Family 12
 4 Simon of Cyrene and his Wife 13
 5 Herri met de Bles: The Carrying of the Cross 14
 6 Landscape with Walled Town 17
 7 Brothers Limbourg: June 18
 8 Bruegel: Summer 19
 9 Bosch: Hay Wagon detail 22
10 Geertgen tot Sint Jans: figure detail 23
11 Bruegel: figure detail 23
12 Christ and the Woman Taken in Adultery 25
13 Van Eyck: flower detail 26

THE PLATES

 1 Landscape with Christ
 2 Landscape with the Fall of Icarus
 3 Landscape with the Parable of the Sower
 4 View of Naples
 5 The Tower of Babel
 6 The Procession to Calvary
 7 The Procession to Calvary (detail)
 8 A Gloomy Day
 9 A Gloomy Day (detail)
10 Hay Making
11 Hay Making (detail)
12 Hay Making (detail)
13 The Corn Harvest
14 The Corn Harvest (detail)
15 The Return of the Herd
16 The Return of the Herd (detail)

17 The Hunters in the Snow
18 The Hunters in the Snow (detail)
19 Winter Landscape
20 The Massacre of the Innocents
21 The Numbering at Bethlehem
22 The Numbering at Bethlehem (detail)
23 The Conversion of St. Paul
24 The Conversion of St. Paul (detail)
25 The Magpie and the Gallows
26 The Netherlandish Proverbs
27 The Fight between Carnival and Lent
28 The Fight between Carnival and Lent (detail)
29 Children's Games
30 Children's Games (detail)
31 Children's Games (detail)
32 The Triumph of Death
33 The Triumph of Death (detail)
34 The Dulle Griet
35 The Dulle Griet (detail)
36 Head of an Old Peasant Woman
37 The Adoration of the Kings
38 The Wedding Dance in the Open Air
39 Peasant Wedding
40 The Peasant Dance
41 The Land of Cockaigne
42 The Land of Cockaigne (detail)
43 The Corn Harvest (detail)
44 The Parable of the Blind
45 The Parable of the Blind (detail)
46 The Parable of the Blind (detail)
47 The Cripples
48 The Misanthrope
49 The Peasant and the Birdnester
50 The Peasant and the Birdnester (detail)
51 The Storm at Sea

Introduction

'The Master does not seem to occupy his rightful place in the public mind. It is to be feared that even to mention Jan van Eyck and Bruegel in one breath may sound provocative.' (Max Friedländer 1916).

'Jan van Eyck, Pieter Bruegel the Elder and Rubens appear to our time as the three dominant figures of Flemish painting.' (Fritz Grossmann 1955).

As late as 1916 Max Friedländer, one of the greatest experts on Netherlandish painting was well aware that his own views on Bruegel were still very much minority ones. The years between 1916 when his book *Die Altniederländische Malerei* was first published and 1955 when Fritz Grossmann's book *The Paintings of Bruegel* first appeared have brought about a complete change in public opinion. Today anyone who has examined even a small number of the master's works will almost certainly agree with Grossmann's words. Although Bruegel's art remains something of an enigma the tremendous strides in our understanding of it are among the best achievements of 20th-century art historical research.

Moreover, the intense vitality of his art and its underlying pessimism become comprehensible when viewed against the historical and cultural background of his time. For Bruegel lived in a period of acute political and religious strife. The Netherlands, under the rule of Charles V, had formed part of the vast Hapsburg Empire and trade had flourished, particularly in such cities as Antwerp. But when in 1555 Charles V abdicated in favour of his son, Philip II of Spain, the Netherlandish Inquisition which had previously been lenient, finally became an instrument of terror and revolution was clearly inevitable. It broke out in 1567, under the leadership of William of Orange and counts Egmont and Hoorn. Supporters came from the lesser aristocracy and the wealthy burghers, but because the rebellion was badly organised it ended with bands of inadequately armed and ill-paid men, nicknamed 'Les Gueux' (the Beggars), roaming the countryside, plundering and looting. All these events must have made a profound impression on Bruegel.

Our knowledge of Pieter Bruegel the man, however, can only be conjectural. Apart from three dates, which include the year of his death (1569), but not of his birth, we are dependent mainly on such information as we do possess by Carel van Mander who in his *Schilderboek* of 1604 devoted a short chapter to him. Just how vague this is is apparent from the outset. We are told that Bruegel was born (no date given) in the little village of Brueghel near Breda in Brabant, that he was the son of a peasant and that he took the name of his native village for himself. Immediately we run into difficulties. There is no village Brueghel near the town of Breda in Brabant. Another suggestion has been put forward for Bruegel's birthplace, namely the village Brögel which lies within a few miles of the little town of Bree, known in the 16th century as Breede or Brida — in its Latin form Breda. This Breda however, is in Limbourg, at that time Liège territory and it has been pointed out that the legal exclusiveness of Antwerp and Brussels, the two towns where Bruegel spent most of his life as an artist, would have imposed restrictions on a foreigner from Liège, a fact which would have been known to van Mander.

The moment serious research on Bruegel began the problem of his birthplace became the subject of heated discussion, for on it depended the acceptance or rejection of Bruegel's peasant origin. Although at the time of the publication of the *Schilderboek* both Bruegel's sons were alive, van Mander apparently had no contact with them. Ludovico Guicciardini's work *Description of the Low Countries*, published in 1567 when Bruegel was still alive, in which he is called Pietro Brueghel di Breda, may have been the source for van Mander's conclusion that 'Brueghel' was not a patronymic but the place of his birth. Bruegel's birthplace and social standing must thus remain a mystery. Was he a peasant, born in a small village with first-hand knowledge of peasant life or was he a townsman born at Breda whose knowledge of peasant life was not a birthright but based on artistic observation?

In addition to his subjects of peasant life van Mander tells us that Bruegel worked in the manner of 'Jeroon van der Bosch' and produced many spookish scenes and drolleries and for this reason many called him Pieter the Droll. 'There are', he continues, 'few works by his hand which the observer can contemplate solemnly and with a straight face. However stiff, morose or surly he may be, he cannot help chuckling or at any rate smiling.' Here again we feel puzzled. Surely the works painted in the 'manner of Bosch', such as the *Dulle Griet* (plate 34) or *The Triumph of Death* (plate 32) are not calculated primarily to cause mirth. Indeed the latter

picture with its stark and threatening landscape in which relentless skeletons ply their grim trade is harsh and gruesome but certainly not funny – at least not to modern eyes. Obviously there are various levels at which Bruegel's work can be appreciated but only to the most cursory glance can they appear amusing. Moreover the pictures Bruegel painted during the last three or four years of his life, for example the well-known *Parable of the Blind* (plate 44) or the small picture known as *The Cripples* (plate 47) are works of tragic intensity however objectively they are presented. A reasonable explanation for van Mander's views might be that he in fact knew few of Bruegel's panel paintings and drawings at first hand but drew his knowledge from the many engravings published by Jerome Cock from drawings by Bruegel. These do include many works of biting satirical wit and some of them share Bosch's fantastic world of monstrous beings. These engravings were immensely popular, widely disseminated and thus easily accessible for study. On the other hand Bruegel's paintings were mainly in the hands of private collectors in various parts of the Netherlands and even in collections outside the Low Countries. Many, as van Mander notes, were in the possession of the Hapsburgs, a large number of which survive and are today in the Kunsthistorisches Museum in Vienna.

In spite of tantalising gaps and some unacceptable interpretations, it is still to the *Schilderboek* that we owe most of our knowledge of Bruegel's life. From this and from all other available sources the following picture emerges of the artist. Nothing is known of his childhood. He was apprenticed to Pieter Coeck van Aelst, a celebrated Mannerist painter of the day, and he was accepted as free master in the painter's guild at Antwerp in 1551. The date given by van Mander is confirmed by the surviving guild lists for that year in which the entry in question reads 'Pieter Brueghels'. If his training followed the usual course at that time he must have been about 25 years old which would place the year of his birth as around 1526. In fact he may have begun his apprenticeship rather later than was customary as he may have had some previous training before joining Pieter Coeck. Recent evidence indicates that he was probably in the workshop of Claude Dorizi in Malines, and it is there he may have started to study the then popular art of watercolour painting on fine linen. The fact that Mayken Verhulst Bessemer, the second wife of Coeck and later Bruegel's mother-in-law, was among the most famous practitioners of this form of art there, is perhaps more than mere coincidence. Bruegel, whose earliest known paintings were in watercolour and who frequently used very thinly applied, almost transparent colours, especially in his landscape backgrounds, may actually have been a pupil of Mayken Verhulst and through her have been introduced to Pieter Coeck. Coeck who had an important workshop at Antwerp seems to have spent the last years of his life at Brussels where he died in 1550. His widow and small daughter – according to van Mander, Bruegel had frequently carried her in his arms when she was a baby – remained in Brussels but Bruegel chose to settle at Antwerp and, as we have seen, became free master there in 1551. It may have been at this time, too, that he established contact with Jerome Cock the famous publisher and distributer of prints although there is no proof of this until 1555-6 when engravings after Bruegel's drawings were first published by Cock. The first of these engravings known today was a mountain landscape dated 1555. Better known is the first engraving with figures taken from a drawing by Bruegel signed and dated 1556 and published by Cock as an invention of Jerome Bosch: *Big Fish eat little Fish* (figure 2).

Probably in 1551, immediately after he became free master, Bruegel set off on an extensive journey to Italy travelling via France and perhaps taking the sea route from Marseilles to Naples. He seems to have reached Naples around 1552 and continued South as far as Sicily. Some of the places he visited can be confirmed by existing or recorded drawings, engravings and paintings. He was in Reggio in Calabria in 1552 in time to witness the fires that broke out in the town after the Turkish fleet had attacked it in 1552. A drawing of the burning town was used for the engraving the *Naval Battle in the Straits of Messina*.

Two etchings by Joris Hoefnagel inscribed 'Petrus Breugel (sic) fec: Romae A° 1553' show that Bruegel had reached Rome by 1553 and this is confirmed by his association in that year with Giulio Clovio then at the height of his fame as a miniaturist. This association may have been a professional one as Bruegel will have certainly had to earn his living during his protracted stay in Italy and Clovio, himself a

Croatian, seems to have frequently assisted young foreign artists. But whatever their relationship was, Clovio undoubtedly valued Bruegel's work very highly and retained several examples of it. In his estate inventory of 1578, paintings and drawings by Bruegel are listed including a painting on ivory of the Tower of Babel and a picture 'Un quadro di Leon di Francia a guazzo di mano di M° Pietro Brugole' (a view of Lyons in France, painted in watercolour) which confirms Bruegel's early journey via France.

Bruegel's return journey is undocumented but he certainly travelled via the Alps and Switzerland as can be seen from surviving drawings. His first contact with Alpine scenery must have made a tremendous impact. Carel van Mander describes it vividly: 'On his journeys Breughel did many views from nature so that it was said of him, when he travelled through the Alps, that he had swallowed all the mountains and rocks and spat them out again, after his return, on to his canvases and panels'.

After his return to Antwerp Bruegel was kept busily employed supplying Jerome Cock with drawings for engravings and these included landscapes as well as figure subjects. Bruegel remained based at Antwerp until 1563. In that year he married Mayken Coeck and moved to Brussels where he remained until his premature death in 1669. There are various theories to account for Bruegel's move to Brussels. According to van Mander his future wife's mother, Mayken Verhulst, insisted on it as during his stay in Antwerp he had lived with a servant girl whom he even wished to marry. The girl, however, was a great liar and this Bruegel could not tolerate so he made a pact with her. He took a stick, choosing a long one, and each time he caught her out in a lie he said he would cut a notch in it. Once the stick was full he would turn her out but if she stopped telling lies he would marry her. The girl was unable to speak the truth and in a short time the stick was full and she had to leave. Mayken's mother, however, was not satisfied that the affair was really over and as a precautionary measure insisted on the move to Brussels. Whether true or not the story does suggest that Bruegel was known as a great lover of truth – a characteristic one would expect from a study of his art. In any case the wishes of Bruegel's mother-in-law can only have been a contributary factor in Bruegel's momentous decision to leave

the town where he had worked so successfully and established a considerable reputation for himself.

The reason may lie in the fact that Antwerp had become a centre for free thinkers and members of the Libertine sects who advocated religious freedom. These men, the intelligentsia of Antwerp, were the heirs of the enlightened thinkers of the early part of the century, such as Erasmus of Rotterdam, and they included important personalities like the publisher Jerome Cock, the world famous geographer Abraham Ortelius, and the printer Plantin who came under suspicion of heresy just at that time. With these men Bruegel must have discussed ideas for his pictures although he himself remained true to the Roman Catholic faith and was patronised by Cardinal Granvelle, the all-powerful Catholic minister of Philip II in the Netherlands. In spite of this he may have deemed it wise to leave Antwerp before coming under suspicion. Antwerp, though still an international centre of the first order, had nevertheless passed the peak of prosperity.

From 1563 on Bruegel was centred in Brussels and it was there that his marriage to Mayken Cock was celebrated as can be seen from the marriage registers of Notre Dame de la Chapelle. In Brussels Bruegel worked most intensively as a painter and there he painted some of his greatest pictures, including the series of the *Seasons* (plates 8-19) of 1665 and, in a more tragic vein, the already mentioned *The Parable of the Blind* and *The Cripples* both dated 1568. He was commissioned by the Brussels Councillors to paint some pieces to show the digging of the Brussels-Antwerp canal. But his death interfered with the work. Van Mander tells us that 'many of his compositions of comical subjects, strange and full of meaning, can be seen engraved; but he made many more works of this kind in careful and beautifully finished drawings to which he added inscriptions. But as some of them were too biting and sharp he had them burnt by his wife on his death-bed, from remorse or for fear that she might get into trouble or have to answer for them'. The latter suggestion may be true for when we consider that in 1567 Philip II appointed the notorious Duke of Alba governor-general of the Netherlands and that the following year he set up the tribunal known as the Council of Troubles, popularly and for good reason nicknamed the Council of Blood, we can well appreciate Bruegel's fears – however much we may deplore

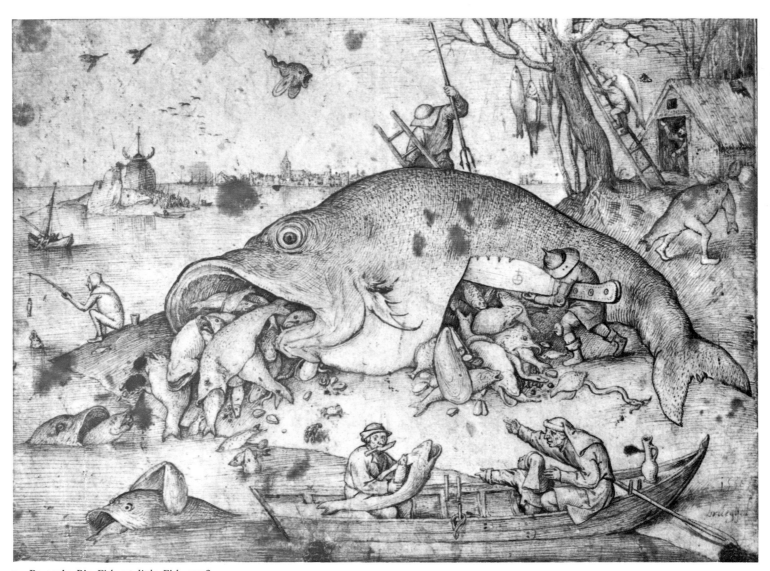

2 Bruegel: *Big Fish eat little Fish.* 1556.

the loss of the 'beautifully finished drawings'.

It has been suggested that many of Bruegel's works, in addition to the ostensible subject matter, contained veiled allusions to the political events of the day, but the most obvious one, *The Massacre of the Innocents* (plate 20) can have no reference to Alba as he was not yet in the Netherlands at the time it was painted, *c.* 1565-6. Moreover, though the chaotic conditions in the Netherlands must have made a profound impression on Bruegel, his pictures seem to contain a castigation of sin as applied to the individual rather than a covert attack on the tragic situation or on any one party.

As far as Bruegel's character is concerned, we have already concluded from the anecdote of the servant girl that he was an unusually truthful man. A few more hints are given in the *Schilderboek* which contains the rather contradictory statements that 'he was a very quiet and thoughtful man not fond of talking, but ready with jokes when in the company of others. He liked to frighten people, often even his own pupils with all kinds of spooks and uncanny noises'.

Apart from the fact that Bruegel worked intensively for the publisher Jerome Cock of Antwerp and supplied him with drawings for engravings, both single sheets of landscapes and figure compositions as well as series depicting the Virtues and the Vices, we know very little about the manner in which he sold his paintings. One of his close friends was a German merchant Frans Franckert who in addition to the social relationship may have acted as his agent. On the other hand some of his pictures were certainly commissioned ones. Of the famous collectors of the day Cardinal Granvelle owned a large collection of his works, drawings as well as paintings, and we know that he valued them very highly. Another collector, the wealthy and influential Niclaes Jonghelinck will certainly have commissioned most of the many works by the artist that he owned. At one time he had no less than sixteen pictures, including the series of the Seasons. Niclaes Jonghelinck was the brother of the then celebrated sculptor Jacques Jonghelinck who stood high in favour with Cardinal Granvelle and was a personal friend also of Bruegel, so that Bruegel's initial introduction to the cardinal may have proceeded via the Jonghelincks. It may have been his increasing success as a painter that led Bruegel to devote more and more time to this form of art, for though a few pictures dating from

his early years have recently come to light, the continuous series of panel paintings does not begin until about 1559. From that year on until his death in 1569 he painted the works by which he is best known today. It is from these mostly signed and dated pictures, as well as from the many surviving drawings, that modern research has reached many interesting conclusions on the personality as well as the artistic importance of Pieter Bruegel.

BRUEGEL THE ARTIST

In his own day Bruegel was certainly regarded as a successful artist but his fame could not compare with that of the contemporary Italianate Netherlandish painters such as Frans Floris. His appeal was mainly in two directions. Firstly, and this was almost entirely due to the engravings from his designs, the man in the street appreciated his robust and satirical 'broadsheets' with their often rather coarse humour and vivid imaginative world of demonic and fantastic beings, and secondly a small but highly cultured group of wealthy and aristocratic patrons collected his pictures avidly and continued to demand them even after his death. So much so indeed that his son Jan Bruegel the elder was unable to find a picture for the Archbishop of Milan, Cardinal Federigo Borromeo, and could offer him only one he owned himself. If we are to judge from the laudatory poem on Bruegel written by his friend Abraham Ortelius in his *Album Amicorum* such patrons had far more understanding for the true value of Bruegel's art than those writers such as Guicciardini or Lampsonius who regarded him as another albeit greater Jerome Bosch.

To appreciate Bruegel's true position as an artist we must cast a brief glance at the artistic climate in the Netherlands both before and in Bruegel's day. During the 15th century when Netherlandish art was at its height the leading painters beginning with Jan van Eyck and the Master of Flémalle (Robert Campin) had established an independent and highly original school of painting, based on northern tradition, close observation of nature and everyday life and a highly developed feeling for space and light that was in sharp contrast to the early Italian Renaissance work. In fact classical antiquity and humanistic idealism which were such essential factors in *quattrocento* Italy were completely

outside the field of interest of Flemish painting. But by the end of the century the position was changing. More and more Flemish painters began to visit Italy and knowledge of Italian art was further introduced to the Netherlands by a growing influx of engravings by the great Italian Masters disseminated by the major publishing houses – a leader in the field was Jerome Cock. By the turn of the century few Flemish painters were interested in carrying on the old native tradition of the 15th century though there were one or two notable exceptions such as Geertgen tot Sint Jans and Jerome Bosch. By the time of Bruegel's birth the Italianate trend in Flemish painting had become fashionable. The often superficial art of Mannerist painters like Jan Gossart Mabuse or Barendt van Orley, the teacher of Pieter Coeck van Aelst, Bruegel's own teacher, was much in demand. It was now expected of any ambitious young painter that he should travel to Italy to gain first-hand knowledge of the great Italian masters. Bruegel, too, visited Italy but he was stimulated in entirely different ways than were his contemporaries, immediate predecessors and followers. The majority of the art patrons were anxious to have paintings with mythological or historical subjects, nude figures and portraits, in none of which subjects Bruegel showed any particular interest. He followed the older Flemish tradition which at that time was kept alive by the watercolour painters on fine linen whose work was popular as a cheaper form of tapestry – Dürer called such paintings 'steyned cloth'. It has been pointed out that in many of Bruegel's early drawings for engravings and figure paintings there is a distinct resemblance in composition to tapestry designs, for example the high horizon or the scattering of the figure groups throughout the picture and his frequent use of very thin colour has already been noted.

But Bruegel is linked with northern tradition also in another field. Much of his earlier work, as we have seen, consisted in designs for engravings with which he supplied Jerome Cock. And Cock in addition to publishing works of the Italian and Italianate masters was also interested in a type of art which would appeal to a less educated public. Here there was ample material for Bruegel to study. During the earlier part of the 16th century alongside the artists who sought fame in the 'higher' sense, were others less well known including some of the so-called 'Little Masters' who specialised in the graphic arts. They were content to develop certain aspects of the 15th century which had first been systematically studied in the Netherlands. The early Flemish painters, beginning with the Master of Flémalle, had set their religious pictures in everyday surroundings. The Annunciation for instance took place not in a church but in the room of a typical Flemish home with contemporary furniture and objects in daily use. Naturalistic details were for the first time observed in their true environment and thus a picture of the way people lived emerged as it were as a secondary product of the religious picture. Although at this early stage the emphasis remained on the content of the work and indeed the apparently ordinary details were given symbolic meaning, nevertheless in the course of time these details became themselves the chief theme for the artist. An example in the late 15th century can be seen in an engraving, by the German artist Martin Schongauer (figure 3) showing a peasant family going to market in which the peasant leads his wife and child riding on a donkey, the composition for which is derived from the formula for the Flight into Egypt. But gradually the artists emancipated themselves entirely from such religious models and turned directly to life. This development applied also to landscape painting for which there had always been particular interest in the Netherlands. In addition to the composite landscapes of a more generalised type, built up to a more or less set formula with foreground middle distance and background following the Flemish Mannerist style, a more intimate study of the Flemish homeland appeared in which the countryside with its villages, farms, cottages and churches was lovingly portrayed in drawings and engravings. Even before Bruegel's day such works were inscribed on occasion with the words 'Naer het Leven', that is 'from life'.

Bruegel developed such landscapes with conspicuous success. Real Flemish villages in sunshine or snow appear over and over again in drawings and paintings throughout his life. They form background or setting to the most varying types of subjects even when these refer to Biblical events remote in time and place. In addition to these intimate portrayals of nature he was equally interested in depicting a grander, more monumental type – Alpine scenery, rivers, valleys and also seascapes. But in all his landscapes there is

3 Martin Schongauer: *Peasant Family going to Market.*

the same feeling of reality. Generally he peopled them with small almost inconspicuous figures or, as often in his later pictures, with large scale ones and these figures evoke the same feeling of aliveness, of real people moving in a real space. In order to achieve this he made a large number of studies which he also inscribed 'Naer het Leven'. They consist mainly of drawings of ordinary folk, peasants, market women, soldiers, burghers, beggars, cripples, horses and so on, in fact a cross-section of the men and women of his day, seen from all angles, sitting, standing, and above all moving. Bruegel probably drew these figures in chalk from life and then completed the drawings in his studio with dark and light brown inks.

Only a few such studies can be identified in his finished works, mainly in the engravings, but obviously in this way Bruegel learnt how to make his figures absolutely natural

and convincing. They helped to give his religious, didactic and moralising subjects a greater impact. The spectator was directly involved in the scene he contemplated because he recognised himself and his neighbours in them. It has, moreover, frequently been noted that in his religious pictures the leading characters are often difficult to detect, lost amidst the crowds of subsidiary figures. Such subsidiary figures are vividly portrayed as real people whilst the holy personages are given in the traditional manner and appear slightly unreal. A good example of this is *The Procession to Calvary* (plate 6) in which crowds of people throng the countryside on the way to witness the execution as a kind of holiday. The figure of Christ is difficult to detect though in fact it is in the centre of the composition, a tiny figure submerged beneath the Cross, almost unnoticed by the crowds apart from the small group in his immediate vicinity. Such a conception was not new. The same subject, for example, known from several versions (figure 4) by Herri met de Bles shows a similar treatment. But the difference between the two works is striking. Herri met de Bles's picture lacks the tremendous vitality of Bruegel's, the figures are stiff and their movements do not flow freely and naturally. The conception is still basically medieval with no sense of an event taking place in front of one's eyes. One of the innovations in Bruegel's version is that it suggests to the onlooker that he is actually witnessing a scene from contemporary life. This is particularly striking in the episode with Simon of Cyrene (figure 5) on the left hand side which is being watched with varying degrees of curiosity and interest by many of the people. The soldiers are trying to drag him forward to assist Christ, he is resisting fiercely and in this is being fanatically supported by his wife whose small mean mouth is tightly folded and her expression venomous. The whole scene in fact attracts far more attention from the spectators than does the main theme of the Procession to Calvary. The detail is particularly striking because, in addition to the contemporary costume they wear the woman has a rosary, another anachronism, at her belt, which hangs upside down with the cross at the bottom – according to some theories this is a symbol of the topsy-turvy world.

Both Bruegel and Herri met de Bles set the scene in a wide landscape with buildings in the far distance and Gol-

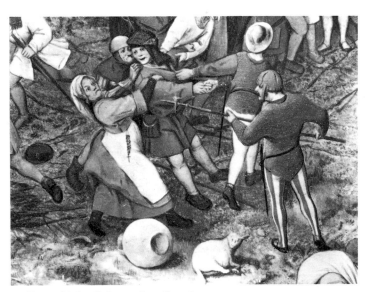

4 Bruegel: detail from plate 6. 1564.

gotha on the right, the site of the Crucifixion emphasised by a circle of spectators already waiting. In Bruegel's case only two crosses are erected with an empty space in the centre awaiting the Cross carried by Christ. This is not the case with Herri met de Bles where in the far distance all three crosses with their occupants are visible. The two parts are divided by steep craggy rocks. Here again Bruegel reveals himself as the innovator. Herri met de Bles still uses the older Flemish Mannerist formula of the three grounds mentioned above. The rocks are symbolic rather than realistic and stand out sharply against the skyline, without merging into the other parts of the landscape. The symbolism is accentuated by the imposing church crowning the peak. Bruegel's central rock on the other hand is convincingly real and crowned by an ordinary windmill, the arms of which are so drawn as to suggest, almost casually, a cross. Moreover the splendid spacious landscape is bathed in uniform atmospheric air and light. The three grounds blend imperceptibly and the distant background seems to merge into the skyline creating a sense of depth and endless space. This magnificent setting with the delicately painted trees and grasses on the left hand side catches at the top the full effect of the bright sunlight

whereas the corresponding part on the other side, where the people are heading for the Crucifixion site, is bleak and almost bare of vegetation apart from a few dead trees. Here too the sunlight shines on the hill top but the clouds are massed above. It is obvious that this is not a real landscape but one put together from various elements and fused into an apparent entity, the type of landscape that Novotny in his book on Bruegel's *Seasons* calls a 'Mischlandschaft' (a composite landscape).

There can be no doubt that Bruegel as an artist responded more passionately and more creatively to nature than did any of his immediate predecessors or contemporaries and it is in this field that his influence is most directly perceptible for the future. He forms a link between the more medieval spirit still inherent in the work of his own day and the new art of the 17th century It is true that a number of his followers and imitators developed what one might call the picturesque side especially of his winter scenes – but this does not apply to the greatest of all 17th-century painters, Peter Paul Rubens. Rubens was a great admirer of Bruegel and painted a picture *Christ's Charge to St. Peter* to adorn the epitaph erected by Jan over his father's tomb. It says much for the scope of Rubens's genius that he, the most Italian orientated of artists should have had such appreciation and understanding for his 'anti-classical' predecessor. The debt is particularly evident in the landscapes, where broad sweeping diagonals cut across the three grounds to create a single piece of nature; an example is the *Château de Steen* in the National Gallery. He even adapts individual motifs from Bruegel's pictures, the best known example being the three women haymakers in his *Return from the Fields* which is obviously based on the figures in Bruegel's *Hay Making*.

Since the earliest dated works by Bruegel – two are dated 1552 – are landscape drawings it really does seem that landscape was his first love. Some fifty such drawings survive, including the splendid series of Alpine scenery of the so-called 'large series' and the exquisite Flemish landscapes of the 'small series'. Though many of these drawings were made for engravings they were all spontaneous expressions of Bruegel's personal response to nature. They are, from the beginning finished works of art in their own right and it is generally assumed that Bruegel used such drawings as

5 Herri met de Bles: *The Carrying of the Cross. c.* 1545.

references for his composite landscapes. Such finished landscape drawings by Bruegel owe much to those of his slightly earlier contemporaries such as Matthys Cock, the brother of Jerome Cock and to the Venetian, Domenico Campagnola, as has often been noted. He may also have looked back to the German 'Danube School' artists who specialised in rather romantic landscapes and to other Flemish painters like Joachim Patenier who had taken certain religious themes such as St Jerome in the Wilderness as a pretext for building up fantastic rocky scenes which have an almost cosmic quality. But Bruegel far outstrips all these prototypes by transmitting to us his own feeling for the majesty of Alpine scenery. Nature seems to live and breathe in detached grandeur and to be utterly remote from human beings. In his *Landscape with Walled Town* (figure 6) the buildings in the middle distance seem to partake of the same quality of permanence which his mountains have. This drawing is unusually rich and varied in detail for its early date, but despite the presence of human beings it can really be classed as pure landscape.

Bruegel's earliest known paintings, too, are landscapes. Grossmann publishes a small picture, *Landscape with Sailing Boats and a Burning Town* from a private collection for which he suggests the date 1552-53, which means it was probably painted in Italy. A second painting has also come to light only fairly recently (plate 1). Other paintings that can be dated before the well known sequence of Bruegel's pictures begin, *c.* 1559, include the *Parable of the Sower* and the *Fall of Icarus* (plates 2, 3). In these early works the emphasis is still very much on the landscape, with the figures small and submerged in the overwhelming grandeur of the setting. This is, of course, a very different conception from the one in *The Procession to Calvary* mentioned above, where the scene is filled with thronging crowds and it is this crowd of human beings, not the landscape, which swamps the figure of Christ.

Although in his later work Bruegel continues to use landscape settings the figures assume far greater importance. But of all Bruegel's painted *oeuvre* only three works, two *grisailles* and one in colour are known today in which landscape does not occur in some form or another. The works in question are all large-scale figure subjects from the New Testament. *The Adoration of the Kings* in the National Gallery, London, is the most Italianate in composition of all Bruegel's

works (plate 37). The elongated figures and complex linear rhythms as well as the crowded figures awkwardly massed in the comparatively small opening on the left show the influence of Italian Mannerism. An Italian motif is the use of objects such as the hat and baton in the foreground to act as *repoussoirs*, which draw the eye forward into the picture space. But the figures themselves are purely Flemish. The buxom full-faced Madonna is far removed from the gracious lady of Italian art and the coarse, robust followers of the king are more like Flemish peasants, workers and soldiers than a courtly suite of royal escort. The other two works are *The Death of the Virgin* and *Christ and the Woman taken in Adultery*.

In all other known cases, as has already been noted, landscape plays some part, often a highly important one. The paintings which most readily come to mind in this connection are the series known as the *Seasons*. Today five paintings belonging to this series have survived and the question as to whether the original set comprised twelve or six pieces is still an open one (for a more detailed discussion of the problems involved see the notes to plates 8–18). In any case there can be no doubt as to Bruegel's intention when he painted the series which was to give a picture of the changing aspects of nature represented by the different landscapes. It is the landscapes themselves and not the people working in them that constitute the main theme. The stirrings of new life can be sensed beneath the bleakness of the bare trees, sluggish water and stormy skies in *A Gloomy Day* (plate 8), a kind of foreshadowing of spring (*Vorfrühling* is the German term). The next phase in the cycle is missing. It would presumably have shown the full awakening of nature to new life. In the two surviving pictures representing the summer months (plates 10 and 13) nature in full fertility is depicted in the Prague picture known as *Hay Making* and the merciless heat of the blazing sun in August is seen in *The Corn Harvest* in the Metropolitan Museum, New York. The next two pictures show the final stages of the series. The rich golden brown tints of autumn in *The Return of the Herd* (plate 15) do not conceal the fact that the vegetation is already dead or dying. The earth is dead, covered with a blanket of snow and ice in the last work known as *The Hunters in the Snow* (plate 17). In this way the full cycle of nature is complete from the first stir of new life to the final extinction beneath the snow. That

this was the main aim in Bruegel's paintings finds further confirmation in the use of colour and in the extraordinary subtlety with which Bruegel can suggest the time of the year, such as the icy cold of winter by the contrast of the white snow and the black bare trees which loom up in the foreground in *The Hunters in the Snow*. Here the colours are basically black steel-blue and white in varying degrees of purity, cold colours that in their combination and contrasts evoke the necessary effect for the spectator. In contrast to this the intense heat of the summer scene in *The Corn Harvest* is expressed not by the brilliant sunlight but by a kind of faint haze that seems to render landscape and human beings alike limp and lethargic. The warmer yellow gold tones of the two summer pictures, whereby the slightly heavier shades in *The Corn Harvest* already indicate the parching effect of the boiling late summer sun, are in marked contrast to the rendering of winter cold, or the browns and bright blues in *The Return of the Herd* which suggest the sharp clear atmosphere of an autumn day.

In this famous series of landscape paintings by Bruegel we must emphasise once again the fact that it is only in his interpretation of the subject that the artist appears as an innovator. The idea of representing the calendar of the year in a series of pictures is an old one. In fact it goes back to medieval times and was one of the most popular subjects for book illumination. These works, however, are conceived not as a cycle of nature but as the relationship of man to nature and they take the form of showing the appropriate 'labours' that man has to carry out in each of these months. It is instructive to see just how closely Bruegel looked at such early examples and in what way he transformed their medieval spirit. The best and most celebrated example is the famous *Les Très Riches Heures du Duc de Berry*, today preserved in the museum at Chantilly. It was originally made for that most fanatic collector, the Duc de Berry, by the Brothers Limbourg. These famous artists of the Franco-Burgundian school originally came from Limbourg in the Netherlands and thus were in a way ancestors of Pieter Bruegel. The most famous part of their book is the illustrations for the calendar, a series of twelve miniatures showing the occupations of each month. Here too the landscape plays a great part and for the period in which it was produced, round about 1400, appears amazingly progressive. But a comparison between Bruegel's *Hay Making* and the illustration for the month of June in *Les Très Riches Heures* (plate 10 and figure 7) shows the new spirit of Bruegel. He has transformed the older work with its basically symbolic conception into a real piece of nature. The religious implication, such an essential feature of the older work, is entirely absent in the later example. Nature for the Limbourg brothers is subordinated, just as the human being is, to a higher divine order. The three reapers on the right, set immediately below a large cathedral, illustrate this. Bruegel's three haymaking women (plate 11) are completely alive and give no suggestion of religious symbolism, and yet in some curious way they seem to hark back to the earlier work, almost as if he were consciously using a similar theme in a new way. In fact the workers in all Bruegel's pictures have no hidden relationship with the landscape in which they work. For them each season brings its own tasks which they carry out by the sweat of their brow and they are indifferent alike to the beauty or harshness that surrounds them. They are brilliantly observed types unsentimentally depicted and unimportant for the overall significance of the landscape itself. Nature has her own life and conforms to her own laws regardless of the human predicaments. Such a conception is far removed from the medieval spirit.

Bruegel's interest seems to have been stimulated by illustrated manuscripts. In Rome we remember he had worked with Giulio Clovio, the famous illuminator. And we know from Clovio's inventory that he owned a little picture by Bruegel painted on ivory – which in fact must have been a miniature.

In addition to the painted series Bruegel also did drawings for engravings of the seasons. These were definitely intended to show not the months but the four seasons, each drawing covering three months. Two by Bruegel survive, *Spring*, dated 1565 and *Summer* dated 1568 (figure 8). The other two were supplied by a different artist, working in Bruegel's manner and the whole series was engraved by Jerome Cock. These two drawings are truly concerned with man's appropriate labours for the season and in this way seem much closer to the earlier manuscripts.

BRUEGEL'S FIGURE COMPOSITIONS

The first surviving works by Bruegel are landscape studies

6 Bruegel: *Landscape with Walled Town.* 1553.

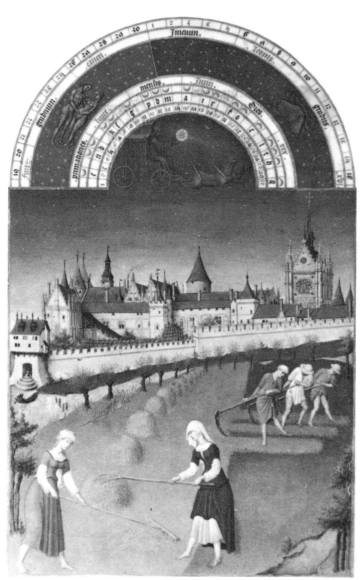

7 *Les Très Riches Heures du Duc de Berry: June.*

and paintings. After his return from Italy and his contact with Jerome Cock he turned also to figure compositions which begin around 1556. By 1559 figure compositions also formed the main themes of his paintings. To begin with these were similar in style and composition to the drawings for the engraved series of the 'Virtues' and 'Vices'. The horizon is taken very high and the figure scenes are scattered over the whole surface while the landscape is mainly restricted to the backgrounds. *The Netherlandish Proverbs* in Berlin and *The Fight between Carnival and Lent* (plates 26 and 27) are both dated 1559. The third work, the *Children's Games* (plate 29) dated 1560, obviously belongs in style to the other two. They are striking examples of Bruegel's originality in the interpretation of subject matter and examples of the strong literary tendency in his art. In their brilliant and satirical narrative style they seem to belong, with their rough and ready humour to the world of Rabelaisian satire. Not that Bruegel in his Proverbs was in any way influenced by Rabelais's *Pantagruel* which was not published until 1564, some five years after the picture was painted, but a preoccupation with human folly was widespread amongst writers at the time, as a reaction against the medieval outlook, where the individual human being's fate was determined by forces of good or evil over which he had no control. Sebastian Brant's famous work *Das Narrenschiff* (Ship of Fools), published 1494, has often been regarded as one of Bruegel's literary sources. Not much later, the most famous humanist scholar of the age, Erasmus of Rotterdam, published his widely-read work *In Praise of Folly*, and this too is regarded as an important source for Bruegel. Underneath the satirical wit lies a deeply pessimistic conception of the world, and this is just what so many people feel to be the underlying sense in Bruegel's figure scenes. Thus there are various levels at which his work can be appreciated. One can simply laugh at the droll antics of the people and enjoy the robust humour with which they are presented – and leave it at that. Or one can look a little deeper and become aware of the more tragic implications of folly and ignorance.

Children's Games is another example of Bruegel's original treatment of a subject for which precedents exist. A vast space has been allotted to the children in which they are scattered in smaller and larger groups, each engaged in a different

activity. Bruegel seems to have collected every kind of game known to the Flemish children of his day and they are playing them with complete absorption, each group entirely oblivious of the activities of the neighbouring ones. It is certainly characteristic of the age in which Bruegel lived that he showed no particular interest in portraying children as such – artists in general depicted them as little adults, with no emphasis on childish grace. Bruegel's children too are treated in this way but their movements and gestures often appear like parodies of those of their elders which heightens the comic effect of the scene (plate 30). Nevertheless the children themselves show none of the carefree aspects of childhood and in a way evoke pity rather than amusement. In a similar way in *The Fight between Carnival and Lent*, the rotund figure of Carnival seated on his barrel does not really seem to be enjoying himself whilst many of his followers are actually wearing tragic masks, and the inclusion of beggars and cripples in the midst of the heedless crowds on the carnival side gives a sinister note to the picture (see note to plate 28).

Bruegel's reflections on the inexorable end awaiting all mankind is expressed only a year or two later in *The Triumph of Death* (plate 32). It is undated but belongs to a group of similar works which include the *Dulle Griet* (Mad Meg) (plate 34) and the *Fall of the Rebel Angels*. All three show a close link with the art of Bruegel's predecessor Jerome Bosch, especially the last two works. Here we find monsters and devils of truly Bosch-like horror depicted in a similarly imaginative manner. But there is a profound difference between Bruegel's world and the still basically medieval world of Bosch. For Bosch, man is threatened by external evil in the guise of demons and monsters, for Bruegel the devils and monsters are let loose by the human being himself, they are his sins and follies which are depicted and, this being the most important point, he is himself responsible for them. In the *Dulle Griet* it is the greed of the housewives who stir up the devils in their anxiety to loot hell itself. In such works the figures are all important and the landscape is merely a pleasant background, as in *The Netherlandish Proverbs*, or else is conceived as a sombre accompaniment to a grim subject as in *The Triumph of Death* or *Dulle Griet*.

That Bruegel liked to depict Biblical themes to illustrate his ideas on the basic folly of human beings is not surprising.

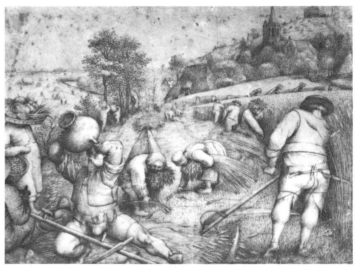

8 Bruegel: *Summer*. 1568.

Thus he painted the Tower of Babel at least three times, once as already mentioned in 1553 when he was with Giulio Clovio in Rome, and later he painted two more versions. The large one is in Vienna (plate 5) and the smaller one in the van Beuningen collection. In both these pictures the contrast between the preposterous, gigantic structure and the peaceful landscape surrounding it with the small houses and details of country life is particularly impressive. The moral is further emphasised by the fact that the building operations are such as would be applicable to building in Bruegel's own day and that the human beings involved are tiny ant-like creatures scurrying around bringing ever more materials for building whilst parts are already burning.

It is understandable that classical mythology should play a very minor role in Bruegel's oeuvre, when he had such a clear cut attitude to life. In fact only one painting with a mythological theme is known today, *The Fall of Icarus* (plate 2). Characteristically enough the subject lends itself admirably to Bruegel's philosophy. Icarus in his pride and folly did not heed his father's warning and flew provocatively close to the midday sun. As a result the wax with which his feathered wings were attached melted and he fell into the sea. Bruegel follows Ovid's version in which a peasant, a

shepherd and a fisherman are mentioned as witnesses to the event. He plays the central theme of the drama down to such an extent that it is extremely difficult to find. At first we see nothing but a very lovely landscape with wide blue sea and delicately painted cliffs receding into the distance. The largest figure, the one to catch the eye first is the ploughman who is proceding with his task of ploughing the field evidently unaware of the drama that has just taken place. The shepherd has his back turned to the slight figure of Icarus who can just be detected lying in the water with one leg sticking up in the air and the feathers of his wings scattered around. He is lying between the large boat ahead of him and the fisherman on the bank who is not paying the slightest attention to him. The poignancy of the contrast between the beautiful, serene landscape and untroubled sea and the subject matter depicted is typical for Bruegel especially in his earlier work. The impersonal quality of nature, her complete indifference to human affairs, to the fact that death has overtaken Icarus who represents human folly, is a completely original conception of the mythological subject.

After Bruegel's move to Antwerp in 1563 a change seems to come over his attitude to nature's role in his pictures. A greater balance between figures and landscape is frequently established. The didactic and moralising tendency, so strong in his early figure compositions, both in the designs for engravings and in the pictures, is less obtrusive and he seems in some cases to depict human tragedy with heightened intensity although he always remains objective and unsentimental. It may be that the personal crisis in his life which came to a head in 1563 is also reflected in his art. Not that he becomes reconciled to the everyday folly and sinfulness of man (the peasant scenes and other works of the later 1560s are evidence of that) but two of his last pictures, *The Parable of the Blind* (plate 44) and *The Cripples* (plate 47), both of 1568, certainly show this intensity. Even his treatment of nature seems to be taking a new and more tragic turn as can be seen from the unfinished picture of *The Storm at Sea* (plate 51), possibly the last work that Bruegel painted. Here the drama of ships tossed on stormy seas is stressed – though this work too has a literary content and the small church silhouetted above the horizon on the left against a clearing in the sky would seem to have a symbolic meaning.

From what has been said so far it is quite clear that the content of Bruegel's pictures is extremely complex, that his personal philosophy and moral outlook as well as his religious views play a vital part in his art. But his genius lies in his ability to express these ideas in terms of art. He was a great painter and a great draughtsman, he had an extraordinary visual memory and a brilliant feeling for composition and the juxtaposition of comic shapes. Furthermore the tremendous vitality of the people he depicts even if they belong to the most miserable types of humanity such as cripples or beggars make an irresistible impact. Whatever they do they do with extraordinary intensity, whether dancing, feasting, playing or looting. The sense of boundless energy, the awareness of life itself as a driving force is one of the most positive aspects of his work as a whole. A striking example of this is *The Peasant Dance* of 1567 in Vienna (plate 40). The whole composition vibrates with the rhythm and force of the movement. Passions run high but the man and woman who are galloping in from the right spare hardly more than a glance at the quarrel that has broken out in the group round the table on the opposite side, a quarrel which has already led to blows. In their eagerness to join the dancing group in the centre they push on with a kind of ruthlessness that contrasts strangely with the delicate foliage of the trees and the peaceful mood of the landscape. Moreover the devotional picture of the Madonna and Child hanging on the sturdy tree trunk above the woman seems incongruous and in fact is completely disregarded by the revellers. The composition is based on diagonals which flow inwards and outwards, towards and away from the sturdy little church building in the background on the right with its steadying vertical lines. The church tower framed by the foliage of the tree with the Madonna picture on the trunk is immediately above the two raised feet of the dancing couple while the man treads heavily and heedlessly with his other foot on the two delicately drawn ears of wheat which seem quite casually to form the shape of a cross.

Almost from the beginning Bruegel shows a preference for the use of diagonal lines in his pictures. In the very early ones such as the *Landscape with Christ appearing to the Apostles* they are not obviously used but already in the *Parable of the Sower* diagonals dominate the composition. In the three large figure scenes (plates 25 - 29) the diagonal arrangement

is striking. *The Fight between Carnival and Lent* has a more diffused composition and the eye is drawn in various directions so that the division between the Carnival and the Lent side is not very clear. *The Netherlandish Proverbs* on the other hand has a clearly defined and strongly emphasised direction, moving sharply from bottom left to top right terminating in the distant river and very high horizon. The *Children's Games*, the latest of the three (dated 1560), has a brilliantly organised composition emphasising convincingly the complete unity of the picture space. The straight lines with abrupt interruptions that create gaps in the continuity of the movement produce sharp corners round which we can move into the different parts of the picture space. The figures of the children with their almost stereometric shapes arranged only apparently haphazardly in scattered groups enhance this feeling of a unified space. In his later work, particularly after his move to Brussels, Bruegel's use of diagonal composition becomes extremely varied, and extremely free. Sometimes, for example in the *Peasant Wedding* (plate 39), it appears as a broad band running right through the picture as the banqueting table with the wedding guests seated on benches and stools. The effect is so natural that we are hardly aware of the boldness of the arrangement. The boisterous mood of the company is emphasised by the upward swing of the diagonal table. In *The Parable of the Blind* the line of blind men leads downwards, emphasising the tragic scene, from the left upper corner to the bottom right one and terminates in the fallen man. His right arm and hand complete the movement and at the same time deflect the eye upwards and backwards coming to rest, significantly, at the church.

A very curious composition which is unique in Bruegel's work can be seen in *The Land of Cockaigne* in Munich, also a late work dated 1567. Here the two ungainly figures sprawled in the foreground thrust in opposite directions across the picture. They are however so placed that their heads converge towards the massive tree trunk supporting the round table in the centre, which is loaded with food. Here again Bruegel's inimitable eye for the comic is superbly expressed in the shapes of the figures. The clerk on the left with his closed book beside him, lying on his back with legs wide apart, was used earlier by the artist in *The Corn Harvest* of the *Seasons* series (plate 13). The two opposing diagonal thrusts termi-

nate in the left upper corner in the house with the tarts on the roof – a motif already used in the *Proverbs* – and on the right in the gruel mountain. The composition as a whole is highly complex, the lines of movement obscured by the convergence of all parts to the table in the middle distance occupying the central part of an elliptical construction which interpenetrates the diagonals. The emphasis in the details is on spherical shapes and curves, all suggesting plumpness, the result of over-indulgence, as do also the figures of the three corpulent men.

In his later landscapes too Bruegel makes use of diagonal composition in amazing variety. The eye is drawn easily in all directions so that we seem to see a living piece of nature before us where every field, meadow, valley, footpath and mountain slope is really accessible and we can move between the rocks and houses and sail along the rivers. Such landscapes are found in the cycle of the *Seasons* and they are also very marked in the later drawings. The use of diagonals is in fact a Mannerist trait and links Bruegel with the art of his own day, both Flemish and Italian. Nevertheless the link is largely superficial since Bruegel uses them in a very positive way to emphasise the pressures of life and the mood of his theme, not to confuse the subject as the Italian Mannerists so frequently did. It may be difficult to detect the protagonists, especially in his Biblical pictures, but they are not played down for esoteric reasons. What Bruegel wants is to give the impression that the scene is being enacted then and there, that it is the spectator of his own day who is implicated, not the people of bygone times.

Although Bruegel's relationship to Italian art was by no means negative he was still anti-classical in his philosophical and artistic outlook. He was not at all interested in the human figure and never tried to idealise the individual. Nude figures for their own sake never occur in his paintings or drawings, not even in the 'Naer het Leven' studies. His knowledge of anatomy was perfectly adequate as can ben see for instance in *The Triumph of Death* where convincing skulls and skeletons fill the painting. But even here he adapts them to the composition, never hesitating to elongate the true proportions of the human skeleton, to be more expressive. But this lack of interest in humanistic ideals does not mean that he was indifferent to Italian art as a whole. For all

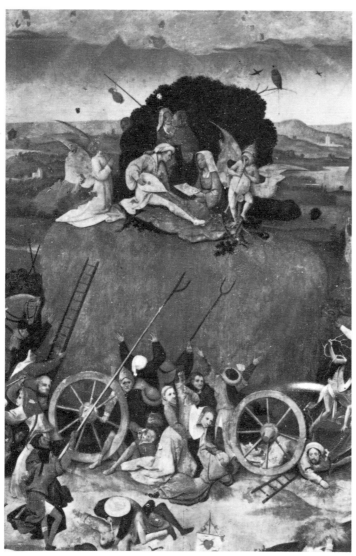

9 Jerome Bosch: *Hay Wain,* detail from a triptych. 1485.

its fundamental differences his own mature form of Mannerism seems much closer to that of the great Italian masters than does the Mannerism of the Italianate Flemish painters of his day. It is merely that Bruegel assimilated the stimuli gained in Italy more slowly.

It may have been first of all a reaction against the rather static monumentality of the High Renaissance that roused his interest in emphasising movement. Already the first works he produced show this. His figures bend, turn, walk or run as they do in real life. There is nothing artificial about them, never a sense that the movement is an arrested one and can never be completed or continued as is so often the case with his predecessors. The best examples for this are to be found in Flemish art, for the interest in everyday life was, as has already been mentioned, developed very early there. But it needed Bruegel's genius to infuse a sense of dynamic life into each figure or figure group. This can be appreciated by comparing individual figures in his work with similar figures by older artists, for example Bruegel's figure of the bending man in the foreground centre of the *Proverbs* (figure 11) who is blocking up the well after the calf has drowned. Here the man is actually in the process of shovelling the stones and the movement is a continuous one. Compared with this the man who is casting bones on to the fire in Geertgen tot Sint Jan's picture of *The Burning of the Bones of St. John* (figure 10), painted at the end of the 15th century and shown in a similar pose, appears almost like a puppet. The bones on his spade are symbolic and the whole action in no way suggests that they will ever really be cast on the flames.

Bruegel's early works contain only small figures and these are not quite so convincingly rendered as they are in his later works, after the move to Brussels. It may be that his studies for the skeletons in *The Triumph of Death* gave him a better understanding of the human form and enabled him to render more complex postures and twists of the body as is shown by the dancing figures of the peasants in *The Wedding Dance in the Open Air*. During these years he often increases the size of his people as in the *Peasant Wedding* or *The Peasant Dance*. Generally speaking Bruegel prefers sturdy compact figures with an emphasis on cubic bulk and weight, and though they are never actually caricatured, the comic element in a posture or movement is always emphasised. On

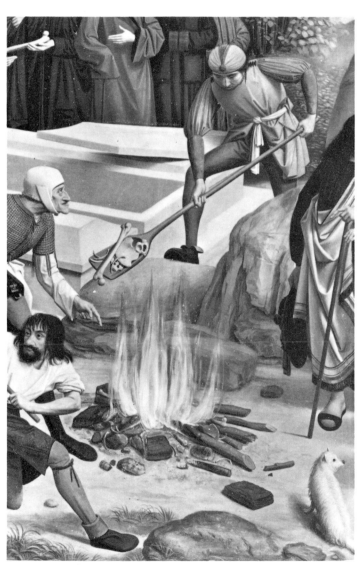

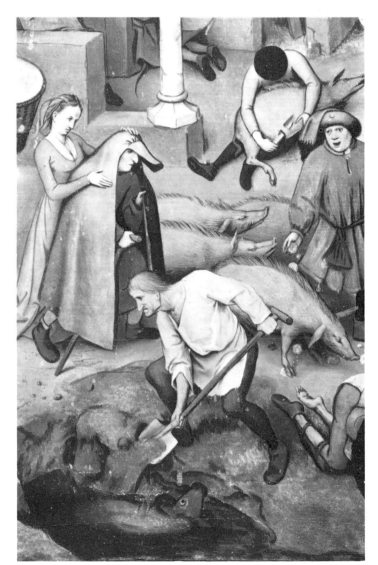

10 Geertgen tot Sint Jans: detail

11 Bruegel: detail from plate 26. 1559.

the rare occasions when he does use overlong figures such as in *The Adoration of the Kings* (plate 37) or *The Woman taken in Adultery* (figure 12) the elongations and poses of the figures, while they suggest in general contemporary Italian Mannerist composition, are quite un-Italian in effect. The Madonna and Child in *The Adoration* have something Michelangelesque in form though the buxom peasant type of the Madonna is purely Flemish. The composition of *The Woman taken in Adultery*, as Grossmann has shown, was derived from a study of the Raphael cartoons showing the Acts of the Apostles, at that time still in Brussels, (today in the Victoria and Albert Museum, London) and more specifically from the one of the healing of the lame man. Furthermore, the expressive treatment of light and shade, in which Christ and, for Bruegel, the unusually attractive figure of the adulterous woman are picked out and opposed to the group of Pharisees, seems to foreshadow Rembrandt. In fact Rembrandt's small painting in the National Gallery, London, of the same subject, suggests very strongly that he had knowledge of Bruegel's picture.

As far as we know Bruegel only paid one visit to Italy, the early journey of *c.* 1551–*c.* 1553. As we have seen, his work immediately after his return shows little influence of what he had experienced there artistically. Indeed the Antwerp period is characterised by its link with native tradition and more particularly by his debt to Jerome Bosch. But Bruegel 'modernised' the content of Bosch's art and gave it a didactic and moralising emphasis. And here again we find a facet of Bruegel's art that has already been mentioned, namely the way in which he continues the older tradition and at the same time transforms it into something new, something which really expresses the conception of the human being as a responsible person. For the first time a northern artist has put into pictorial terms the intellectual and philosophical principles of his day. The oppressive sense of guilt, one of the deeper causes of Mannerism, that burdens almost the entire 16th century is part of Bruegel's own philosophy and he does not hesitate to castigate sin and folly in his art. Later with his artistic genius fully matured, the by now assimilated impressions of Italian art come into their own. And significantly enough it is the greatest of the Italians, Michelangelo and Raphael, who seem most clearly visible in his Brussels

years. And again it is the late work of these artists which affects him most; the Raphael of the cartoons has already transcended the High Renaissance and the Michelangelesque qualities are derived from that artist's late work. We must remember that when Bruegel was in Italy Michelangelo's work in the Pauline chapel had just been completed and these frescoes with their daring diagonal compositions and urgent movements certainly impressed him considerably. The difference lies in the fact that whereas Michelangelo's people are heroic in stature and form Bruegel uses ordinary, often ungainly people from everyday life and gives them a very down-to-earth reality.

Here again Bruegel is in tune with his own age for he never stresses personal tragedy in order to evoke sympathy for any particular individual. This is abundantly clear from the way in which he depicts the most unfortunate members of society. In his early work beggars, cripples and lepers are included among the various groups of people shown, for example in *The Fight between Carnival and Lent* (plate 27). In the last years of his life he devoted two pictures entirely to such miserable outcasts of society, *The Cripples* and *The Blind* (plates 46 and 47). There is nothing sentimental in his presentation. They are shown as a group, not individually, a sight that must have been common enough in his day and the challenge they represented was a general challenge to society as a whole. The figures themselves seem to accentuate this. The cripples appear aggressive in their attitude and seem to be shouting abuse at us. In *The Parable of the Blind* Bruegel is not content to show two men only, one leading the other as would have been necessary to illustrate the Biblical text, but gives a line of six men and the only comment lies in the affliction itself which is presented with almost brutal naturalism. In a similar way Bruegel changes his interpretation of the Netherlandish proverbs. To begin with the subject is treated collectively, that is to say a very large number, (nearly a hundred have been identified) are grouped together in one picture. It is clear that Bruegel enjoyed amassing more and ever more examples of the folly of man in a series of individual scenes unrelated and yet each one part of a unified composition. Everyone is intent on his or her own foolish or evil business and no one spares a thought for the sign that hangs at the entrance to this village of fools, namely

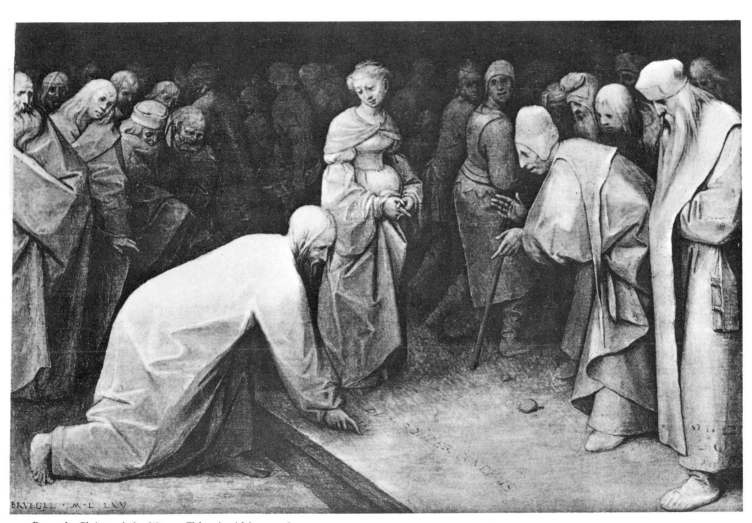

12 Bruegel: *Christ and the Woman Taken in Adultery.* 1565.

the 'topsy-turvy world' in which the globe is shown with the cross at the bottom hanging downwards. In his later period Bruegel is content to treat proverbs individually as *The Peasant and the Birdnester* or *The Misanthrope* (plates 48 and 49).

In all these compositions in which Bruegel appears as an uncompromising exponent of the frailties and sins of his own world which he exposes with detached impartiality the effect is almost always counterbalanced by the extraordinary beauty of the landscape setting. Nature remains aloof from the sins of man and Bruegel shows yet another facet of his artistic genius when revealing her most subtle beauties. For not only is he capable of expressing the full impact of mountain scenery he can also render the intimate charm of delicate foliage or the richness of flowers in full bloom. Bruegel's own visual and emotional response to landscape seems to contain all the tenderness and sensuous charm which is so completely lacking in his figures. Few indeed are the artists before Bruegel who could paint or draw a landscape so convincingly that it is as if nature really comes alive before us. Of all the artists of the early Flemish school Jan van Eyck is the one from whom he could have learnt most. For van Eyck too was capable of rendering with loving skill the richness of flowers and trees and at the same time retaining the unity of the landscape as a whole. One of the best examples of this is the landscape setting for *The Adoration of the Lamb* in the Ghent altarpiece (figure 13). If Bruegel's landscapes are not real ones but put

together from various different pieces they are fully convincing as unified compositions. If in his figure compositions he must be regarded as fundamentally a pessimist, we are justified in regarding his feeling for nature as one of the most positive aspects of his artistic genius. For these landscapes appeal first and foremost in their power to capture our own feeling for the physical beauty of the world.

SELECTED BOOK LIST

Since the appearance of the monumental biography on Bruegel by René van Bastelaer and Georges Hulin de Loo (Brussels 1905-7) studies by scholars have multiplied until today there exists a very considerable *oeuvre*. The views accepted in the present book are based mainly on the researches of Max Dvořák, Wilhelm Fraenger, Max Friedländer, Gustav Glück, Fritz Grossmann, Ludwig Münz, Edouard Michel, Fritz Novotny, C.G. Stridbeck, C. de Tolnay.
The following short list may prove helpful.

Dvořák, M. *Pieter Bruegel der Ältere*, Vienna 1907.
Fraenger, W. *Der Bauern Bruegel und das deutsche Sprichwort*, Zurich 1923.
Friedländer, M. *Die Altniederländische Malerei*, 14 volumes, Berlin – Leiden 1924-1937. *From Van Eyck to Bruegel*. London 1956.
Grauls, J. *De Spreekwoorden van Pieter Bruegel de Oude verklaard*, Antwerp 1938.
Glück, G. *The Large Bruegel Book*, 5th edition, Vienna 1952.
Grossmann, F. *Bruegel Paintings*, 2nd edition, London 1966.
Jedlicka, G. *Pieter Bruegel*, Zurich 1947.
Meyere, V. de *De Kinderspelen van Pieter Bruegel de Oude verklaard*, Antwerp 1941.
Münz, L. *Bruegel Drawings*, London 1961.
Novotny, F. *Die Monatsbilder Pieter Bruegels des Älteren*, Vienna 1948.
Puyvelde, L. van *Pieter Bruegel: The Dulle Griet*, London 1945.
Michel, E. *Bruegel*, Paris 1931.
Stridbeck, C. G. *Bruegelstudien*, Stockholm 1956.
Tolnay, C. de *Pierre Bruegel l'ancien*, 2 volumes, Brussels 1935.
Tolnay, C. de *The Drawings of Pieter Bruegel the Elder*, London 1952.

13 Van Dyck: detail from *The Adoration of the Lamb*. 1432.

Notes on the illustrations

The information given in these notes is based mainly on two publications: Gustav Glück: *The Large Bruegel Book*, 5th edition 1952 and Fritz Grossmann: *Bruegel Paintings*, 2nd edition, 1966. Both writers list the entire paintings by Bruegel which they consider to be authentic works by the master though Grossmann includes one or two early landscapes not then known to Glück and rejects a small number of works incluaed by Glück. Everything illustrated here is accepted by the vast majority of Bruegel experts as authentic though owing to lack of space it has not been possible to include the entire number. Each one of the works omitted would in fact have added another facet to the very varied picture of Bruegel's art which made the choice of what to omit a particularly difficult one. Furthermore, the details in Bruegel's pictures form complete pictures in themselves and can be as it were extracted from the whole composition and presented as works of art in their own right. They give us an idea of the artist's ability to render the most minute details with convincing reality, and of his genius in juxtaposing shapes to form comic relationships, without impairing the overall unity. The details selected here serve the main purpose of illustrating points in the text though one or two (plates 30 and 50) have been included for their own sake.

A large number of Bruegel's paintings and drawings are signed and dated. Up to 1558 the artist always used the form 'Brueghel' with an 'h' for his signature but from 1559 on he dropped the 'h' and used the form 'Bruegel'. No reason is known for this change. He had two sons Jan and Pieter the Younger, both painters, who reverted to the older form and signed 'Brueghel'. Pieter Brueghel the Younger was born in 1564 and died in 1638. He was unoriginal in his art, leaning heavily on his father whose paintings and drawings he frequently copied or adapted. His nickname 'Hell Brueghel' derives from his decided preference for horror and demonic scenes. Jan Brueghel the Elder known as 'Velvet Brueghel', was a much more original artist. He was born in 1568 and died in 1635. It was perhaps a conscious effort to assert his own personality that led him to specialise in small, exquisite little landscapes on copper, brilliant in colour and often charming in mood and conception. Both he and his brother had children and grandchildren who carried on the family tradition of painters with decreasing ability.

THE BLACK AND WHITE ILLUSTRATIONS

Figure 1 *The Painter and the Connoisseur. c.* 1565. Pen and darker and lighter brown ink on paper. 9⅞ × 8½ in. (25 × 21.6 cm.). Albertina, Vienna.
Münz lists four copies of this drawing surviving today, proof of the interest it had aroused. It has been suggested that the painter is a self-portrait but it seems rather to suggest the contrast between the truly inspired artist and the greedy philistine.

Figure 2 *Big Fish eat little Fish.* 1556. Pen and greyish black ink on paper. 8½ × 11⅞ in. (21.6 × 30.2 cm.). Albertina, Vienna.
Preliminary drawing for the engraving by Pieter van der Heyden. This is the first dated drawing for a figure composition by Bruegel to be published by Cock. The first edition bore the inscription 'Hieronymus Bosch inventor'. Münz regards it as a re-drawing by Bruegel after motifs by Bosch. The proverb illustrated here was a widely known one – 'Big Fish eat little Fish'–which Bruegel interprets literally.

Figure 3 *Peasant Family Going to Market.* Engraving after a work by Martin Schongauer.
The engraving is listed in Bartsch as among the lost works by Schongauer but the modern plate is an accurate copy of the original one. See Introduction page 12.

Figure 4 *Simon of Cyrene and his Wife.* Detail from plate 6. See Introduction page 13.

Figure 5 *The Carrying of the Cross* by Herri met de Bles. *c.* 1545-50. Oil on Panel. 17 × 12⅝ in. (43 × 32 cm.). Galleria Doria-Pamphily, Rome.
This little picture shows some similarity with the large painting of the same subject by Bruegel (see Introduction page 13). The figures were probably painted by the Brunswick Master (Jan van Amstel).

Figure 6 *Landscape with Walled Town.* 1553. Pen and brown ink in several tones on paper. 9⅛ × 13¼ in. (23.7 × 33.5 cm.). British Museum, London.

The castle in the centre of the walled town suggests to Menzel the town of Avignon with the Papal palace. The landscape with its mountain setting is a composite one; Münz sees in it an early example of the influence of the Venetian painter Campagnola on Bruegel. See Introduction page 17.

Figure 7 *The Month of June.* One of the illustrations by the Brothers Limbourg from the *Très Riches Heures du Duc de Berry.* Musée Chantilly, France.

Figure 8 *Summer.* 1568. Pen and lighter and darker brown ink on paper. 8¾ × 11¼ in. (22 × 28.5 cm.). Kunsthalle, Hamburg. See Introduction page 19.

Figure 9 *Hay Wagon.* Detail of the central panel of the triptych *The Hay Wain* by Jerome Bosch. Prado, Madrid.

Figure 10 *The Burning of the Bones of St. John* by Geertgen tot Sint Jans. Detail. Kunsthistorisches Museum, Vienna. See Introduction page 26.

Figure 11 *The Netherlandish Proverbs,* detail. 1559. See Introduction page 26 and note to plate 26.

Figure 12 *Christ and the Woman taken in Adultery.* 1565. Panel 9½ × 13½ in. (24.1 × 34 cm.). Count Antoine Seilern Collection, London.
This picture which is one of the few surviving *grisaille* paintings by Bruegel has only recently come to light and was published by Grossmann in the Burlington Magazine. It remained in Bruegel's own family until the death of Jan Brueghel in 1625 and was bequeathed by Jan to Cardinal Federigo Borromeo. The composition is one of the few works by Bruegel in which there is no landscape setting. It shows a well-assimilated form of Italian *contraposto* in the two outer groups and in its superb handling of light and shade foreshadows the 17th century. The head of Christ is also reminiscent of Italian examples whereas the figure of the adultress is more akin to German painting recalling Dürer or even Grünewald. Grossmann sees in it a plea for religious toleration.

Figure 13 *The Adoration of the Lamb* by Hubert and Jan van Eyck. Church of St. Bavo, Ghent.
Detail of flowers under the feet of the Apostles from the central panel of the Ghent altarpiece.

THE PLATES

All paintings are in oil on panel unless otherwise stated.

Plate 1 *Landscape with Christ Appearing to the Apostles at the Sea of Tiberias.* 26½ × 39½ in. (67 × 100 cm.). Private Collection.
The panel came to light comparatively recently and was accepted as an original by Bruegel by Max Friedländer. It was published by Tolnay in *The Burlington Magazine* in 1955 and has been widely accepted by Bruegel experts. The figures illustrating Chapter 21 of the Gospel of St. John are still completely subordinated to the landscape setting.

Plate 2 *Landscape with the Fall of Icarus.* 1555? (Neither signed nor dated). Transferred from Panel to Canvas. 29 × 44½ in. (73.5 × 112 cm.). Musées Royaux des Beaux Arts, Brussels.
The picture was purchased on the London art market in 1912. It is in an unsatisfactory condition and some doubts have been expressed as to its authenticity. A second version which is slightly smaller and which is now in the D.M. van Buuren Collection, seems to interpret the story more accurately. Such details as the presence in the sky of Daedalus, who is not visible in this version, and the fact that the time is shown as around midday confirm this. The figures are still overshadowed by the landscape which, in its unified composition already going beyond the older tradition, suggests a slightly later date than for plate 1. Most scholars agree with an early dating. There is unanimous agreement that the composition as a whole is the invention of Pieter Bruegel the Elder though there is no agreement as to whether both versions are replicas or authentic.

Plate 3 *Landscape with the Parable of the Sower.* 1557. 29⅛ × 40⅛ in. (74 × 102 cm.). Timken Art Gallery, San Diego, California.

The picture illustrates the parable as given in the Gospel of St. Matthew, Chapter 13, verses 3-8. The sower is visible in the left hand foreground scattering the seed. On the right hand side, the crowd has gathered on the seashore and others are just perceptible hastening to join the group.

Plate 4 *View of Naples.* c. 1562-3. 15 5/8 × 27 3/8 in. (39.8 × 69.5 cm.). Galleria Doria, Rome.
This is one of the few surviving works by Bruegel that show a specific place, the town of Naples seen from across the bay. It is also essentially a seascape with great emphasis on the ships and a magnificent effect of the subtle variations of light on the blue waters. Once again, at the end of his life Bruegel painted a picture of the sea (plate 51) this time a stormy one. In the present picture, which was almost certainly based on drawings made on the spot, the square harbour has been turned into a semi-circular one probably for compositional reasons. The date is disputed but many critics regard it as an early work. Although painted pictures of the sea are rare in Bruegel's work his interest in the subject and in depicting boats is evident from their frequent occurrence in his landscape settings.

Plate 5 *The Tower of Babel.* 1563. 44 7/8 × 61 in. (114 × 155 cm.). Kunsthistorisches Museum, Vienna.
The picture, the larger of the two versions said by van Mander to be in the possession of Rudolph II was originally owned by Niclaes Jonghelinck. The smaller version, now in the Museum Boymans-van Beuningen, Rotterdam, shows the tower in a more finished state with smoke billowing through the upper windows and without the presence of Nimrod and his followers, who are to be seen bottom left in this plate. Bruegel painted at least one more version of the same subject when he was in Rome with Giulio Clovio, a miniature version on ivory, but this work is lost. Obviously the subject illustrating, as it does, the pride and folly of man appealed very much to Bruegel (see Introduction page 21).

Plates 6 and 7 *The Procession to Calvary* and detail. 1564. 48 3/4 × 66 7/8 in. (124 × 170 cm.). Kunsthistorisches Museum, Vienna.
In 1566 the painting was listed in the collection of Niclaes

Jonghelinck. It is the largest and one of the best preserved of all Bruegel's surviving works.
See Introduction page 13 for a full description.

Plates 8 - 18 *The Seasons.*
This series consists today of five paintings. Opinions differ as to whether the original set consisted of twelve pictures, one for each month of the year which was the more usual number, or whether each painting represented two months. The only documentary evidence that we have is a deed in which the collector Niclaes Jonghelinck appears in the role of guarantor for a certain Daniel de Bruyne. In the event of de Bruyne being unable to pay his taxes to the city of Antwerp, he, Jonghelinck, pledged his own collection to cover a sum of up to 16,000 Carolus Gulden. Sixteen paintings by Bruegel are listed as well as works by Frans Floris and even one picture by Dürer. Among Bruegel's works are named: *The Tower of Babel, The Procession to Calvary,* the *Twelve Months.* It is of course not clear from this whether the *Twelve Months* meant twelve separate pictures or an unspecified number representing the months. The whole in any case is a masterly interpretation of the changing aspects of nature during the different times of the year. See also Introduction pages 18-19.

Plates 8 and 9 *The Gloomy Day* and detail. 1565. 46 1/2 × 64 1/8 in. (118 × 163 cm.). Kunsthistorisches Museum, Vienna.
If the original set comprised six pieces only then the picture probably represents the months of February and March; if on the other hand, there were twelve pieces in the set then the present one most likely depicted the month of February only. The small boy holding the woman's hand in the group on the extreme right wears a carnival paper crown (see detail). The young peasant in the same group is eating a waffle, greedily watched by the woman, and holds another one in his hand. This, too, suggests the carnival season and indicates the month of February. A little to the left a peasant is cutting branches from a willow tree (see detail) and another figure is shown bending down, apparently gathering bundles of twigs perhaps for firewood. Such occupations could take place either in February or March and the same applies to the repairs to roofs and fences shown

on the left hand side, work which was undertaken in the period just before spring. In front of the 'Star' inn stands a fiddler and a few of the figures are dancing to the music. Whilst therefore much of the human activity suggests the festival season the mood of the landscape has the chill bleakness of a late winter day. The sky is stormy and the river flows sluggishly but with choppy waves that cause the ships to list heavily. The bare trees form an attractive pattern against the clouds, drawn with a delicate touch that recalls Japanese work.

Plates 10, 11 and 12 *Hay Making* and details. 1565. 46 × 63⅜ in. (117 × 160 cm.). National Gallery, Prague.
Formerly the picture bore a false signature that was removed in 1931. The picture represents either the two months June and July, or the single month of June. Novotny compares it to miniatures such as the month of July in the Breviarium Grimani. In Bruegel's painting the three women have just passed a group of peasants in single file carrying baskets of fruit and vegetables on their heads which are entirely covered. They are just passing the wayside shrine and seem to be heading for the village. There is a curious contrast between these 'headless' figures and the unusually clear depiction of the faces of the three women seen from the front. The warmth and richness of the summer landscape evokes a feeling of peace and plenty.

Plates 13 and 14 *The Corn Harvest* and detail. 1565. 46½ × 63¼ in. (118 × 160.7 cm.) Metropolitan Museum of Art, New York.
The picture probably represents the months of July and August. In any case the emphasis is on the harvesting of the corn. The wheatfields are divided into three almost geometrically shaped blocks which appear on the left hand side with men engaged in reaping. On the opposite side grouped round a tree men and women are having their midday rest and meal. Everything suggests the heat of a summer day and the heavy work involved in the harvesting.

Plates 15 and 16 *The Return of the Herd* and detail. 1565. 46 × 62⅝ in. (117 × 156 cm.). Kunsthistorisches Museum, Vienna.

This picture is generally regarded as representing the month of November in which month the cattle were generally driven home from the mountains. It was not, however, a usual subject and Grossmann notes that Martin van Valckenborch in his series of the *Months* now in Vienna, which owes a lot to Bruegel, shows the same subject in the picture which he calls November. The composition is extremely free, the lines of the landscape swinging in broad sweeps across the picture framed on the right by the tall curving tree. This leads the eye down to the group of men led by a horseman who are following the cattle as they wend their way across the foreground and turn in a wide arc on the left hand side to thrust steeply back into the picture. The two men with long poles driving the cattle, checking their rambling movements and herding them in the right direction are superbly natural.

Plates 17 and 18 *The Hunters in the Snow* and detail. 1565. 46 × 63¾ in. (117 × 162 cm.). Kunsthistorisches Museum, Vienna.
Grossmann regards January as the most likely month and in fact thinks that it is the first of the series. Others think of December, pointing to the similarity of the landscape with the skating scenes to that in *The Numbering at Bethlehem* (plate 21) which took place in December. Others again think of February. In any case the occupations refer to the winter months, for instance the pig-singeing in front of the inn on the left, the skating on the frozen ponds and the group of hunters returning home from fox hunting. The picture is not in as good condition as the others of the series and according to Novotny the colours have darkened considerably.

Plate 19 *Winter Landscape with Skaters and a Bird-Trap.* 1565. 15 × 22 in. (38 × 56 cm). Dr. F. Delporte Collection, Brussels.
From about the middle of the 1560s on Bruegel seems to have been particularly interested in interpreting winter scenes and snow landscapes. The present picture, very small in size, was a prototype for 17th-century Dutch snow scenes with skating figures which perhaps owed their immense popularity to Bruegel's prestige. It was said of him that he had in fact succeeded in painting the unpaintable, namely

the actual cold of winter. Whilst the mood of this particular work is unusually friendly, there is the curious motif of the bird-trap with the many birds perched on the bare twigs and on the snow-covered ground. Some of them are rather uncomfortably close to the trap and some actually underneath it and we have the unpleasant feeling that it may fall and crush them at any moment. The fact that the site of the bird-trap counterbalances on the right the carefree activities in the centre and left side does suggest that Bruegel had something more in mind than an interpretation of the joys of winter. The picture is one of the most splendid representations of a snow-clad countryside.

Plate 20 *The Massacre of the Innocents. c.* 1566. 43 × 61 in. (109.2 × 154.9 cm.). H. M. the Queen, Hampton Court.
A second version of the picture, in the Kunsthistorisches Museum in Vienna, was formerly accepted as the original and the Hampton Court picture merely listed among the various extant versions. However recent X-rays of both paintings have shown that whereas the Vienna picture reveals little signs of Bruegel's hand and is at best a workshop painting retouched by the artist, the Hampton Court version is in fact an original though in a sadly damaged condition. Even before the X-rays confirmed his view, Fritz Grossmann had suspected this from a careful examination of the few parts comparatively free of overpainting in the latter work. Later restorers played havoc with the subject matter especially in the Hampton Court picture. Not recognising the real subject matter, they regarded it as depicting Spanish soldiers sacking a Flemish village. Accordingly where the infants had been rubbed away they repainted the parts as animals, fowl, and so on. It is in fact not surprising that the subject matter should have been misinterpreted since Bruegel has brought the Biblical scene into a contemporary Flemish setting, where looting by soldiers was not uncommon.

Plates 21 and 22 *The Numbering at Bethlehem* and detail. 1566. 45 ⅝ × 64 ¾ in. (116 × 164.5 cm.). Musées Royaux des Beaux-Arts, Brussels.
The subject illustrates the account given in St. Luke II, 1 – 5 of the new decree for a universal taxation for which purpose Joseph and Mary went from Nazareth to Bethlehem.

Earlier Flemish artists before Bruegel had depicted the scene of the arrival at the inn but again Bruegel turns it into a contemporary event and sets it in a snow-covered Flemish village. He introduces the theme of the actual taxation, with the Tax Inspector seated at a table in front of the inn and the crowds gathered in front.

Plates 23 and 24 *The Conversion of St. Paul* and detail. 1567. 42 ½ × 61 ⅜ in. (108 × 156 cm.). Kunsthistorisches Museum, Vienna.
This was mentioned by van Mander as in the collection of Emperor Rudolf II. The subject is taken from the Acts of the Apostles 9, 3. The story of Saul's conversion, frequently depicted in Italian art, is again treated in a contemporary manner by Bruegel. A whole army is on the march, soldiers on foot and on horseback are shown climbing up the steep mountain ravine across the entire picture. Saul has already fallen from his horse and lies well back in the picture, a small figure in blue surrounded by a few men some of whom are looking up shading their eyes from the rays of light directed down from the sky above them on the left. The incident otherwise goes unnoticed by the vast majority of the men. Magnificently painted pine trees towering against the rocky mountains direct the eye to the scene (see detail).

Plate 25 *The Magpie on the Gallows.* 1568. 18 ½ × 20 in. (45.9 × 50.8 cm.). Darmstadt Museum.
According to van Mander the picture was bequeathed to his wife by Bruegel. There are various interpretations of the subject beginning with van Mander who writes: 'By the magpie he meant the gossips whom he would deliver to the gallows'. This is not generally accepted today as it seems to have little bearing on the scene represented. This shows a number of dancing peasants moving up the hillside towards the gallows. They do not, however, seem aware of this and continue their dance with heedless abandon. On the left two men are seen pointing to it with outstretched arm indicating that it is the subject of their conversation and their rather swaggering attitude suggests a gesture of defiance. To the right of the gallows and well behind it stands a small wayside cross its arm pointing towards the village, directly

leading to the church. Grossmann sees a religious meaning in the work, others regard it as illustrating the proverb: 'The way to the gallows also passes by smiling meadows'. And indeed the landscape with its rich early summer growth of foliage and luminous stretch of countryside with delicately graded atmospheric light does suggest 'smiling meadows'. The actual technique of the painting is superb. The feathery touch and light prickling touches of colour, especially in the group of trees nearest to the gallows gives a sparkling vitality, and they seem to quiver responsively to the rhythm of the dance. This is unusual for Bruegel who, especially in his earlier work tended to stress the remoteness and indifference of nature to the subject depicted.

Plate 26 *The Netherlandish Proverbs.* 1559. 46 × 64 ⅛ in. (117 × 163 cm.). Kaiser Friedrich Museum, Berlin.
In 1668 the picture belonged to the Antwerp collector Peter Stevens who owned an unusually large number of paintings by Bruegel. Because of its subject matter and the tour de force involved in depicting some hundred Netherlandish proverbs in one picture it has always been one of his best-known works. The subject was popular in earlier Netherlandish art and as Lebeer has shown even the depiction of a hundred proverbs together in an engraving had been done before Bruegel and published in 1558. This bore the title *De Blauwe Huyck* and showed, as does Bruegel's, a woman hanging a cloak round a man as central theme. In Bruegel's *Proverbs* the woman is young and she hangs the blue cloak with head covering round an old man, making a cuckold out of him. *The Netherlandish Proverbs* too was known by the title *De Blauwe Huyck* in the 17th century. Although the individual illustrations of human foolishness are represented as self-contained episodes, the picture as a whole shows a unified composition. See Introduction page 19.

Plates 27 and 28 *The Fight between Carnival and Lent* and detail. 1559. 46 ½ × 64 ¾ in. (118 × 164.5 cm.). Kunsthistorisches Museum, Vienna.
The popularity of the subject in art goes back to the 14th century. The festival of Shrove Tuesday, half religious, half profane, was always celebrated in a spectacular way in the Netherlands and by the 15th century had deteriorated into something of a public orgy. It was bitterly attacked by the Roman Catholic Church but, according to Stridbeck, favoured by the Lutherans. They regarded it as a kind of safety valve for the ordinary people whereas they regarded the emphasis on fasting and outer piety as the typical hypocrisy of the Roman Catholic Church. Stridbeck accordingly sees in the picture an attack on both religions, as neither side are presented in an attractive light. However, the Ash Wednesday side is at least doing good deeds and does seem to come off slightly better. Bruegel was after all a Roman Catholic. Prince Carnival himself, gaily clad in red and blue balancing a large patty on his head is, despite his corpulent rotundity anything but jovial in expression – he has been compared to Falstaff. He sits on a beer barrel attacking his opposite number, Ash Wednesday, personified as a haggard old woman. The underlying feeling of pessimism is counterbalanced by the amazing vitality of the whole, a kind of animal vitality that affects even the beggars. The detail shows the group of disregarded lepers and cripples on the Carnival side, who compare interestingly with those in plate 47.

Plates 29, 30 and 31 *Children's Games* and details. 1560. 46 ½ × 63. ⅜ in. (118 × 161 cm.). Kunsthistorisches Museum, Vienna.
The picture which belonged to Archduke Ernst of Austria in 1594 is mentioned by van Mander. In size it corresponds almost exactly to the two previous works and has much in common in style and setting. It has been suggested that the present picture was planned as one of a series showing the Ages of Man but if so there is no trace of any other works of such a series. Glück gives an interpretation for each of the games and pastimes with which the children are amusing themselves. One detail shows a section of the landscape to the left of the large school house, and the other two children playing who are at once a parody of adults engaged in serious business, and comical in their own right simply as shapes.

Plates 32 and 33 *The Triumph of Death* and detail. c. 1562. 46 × 63 ¾ in. (117 × 162 cm.). Prado, Madrid.
The picture was described in the inventory of Philips van Valckenisse, Antwerp in 1614. Whether this picture is the one

described by van Mander as showing 'expedients of every kind being tried out against death' remains doubtful for there is no question of any attempt at resistance to the inevitable. Bruegel has combined two traditions, the northern one of The Dance of Death and the Italian one showing The Triumph of Death. The Dance of Death in which skeletons lead living people who are powerless to resist them to their inexorable doom was very popular especially in the North during the 15th and early 16th centuries. Perhaps the most famous interpretation in art was the series of woodcuts by Hans Holbein the younger published in Lyons in 1536 which Bruegel could well have known. The idea was to show that death comes to all men, represented by stock types, such as King and Beggar, Cardinal and Knight, Lover and Gamester. Each skeleton approaches his victim with a kind of macabre sprightliness and leads him or her off on the death dance. They were frequently shown with a kind of spine chilling humour that had a direct if primitive appeal. In Italy it was more popular to show the theme as a Triumph of Death over the living. Death, either as a skeleton or as an allegorical conqueror, is frequently riding on a car whose wheels ruthlessly crush the living. To these, Bruegel has added a new theme, the army of the dead as hordes of skeletons attacking the living. Bruegel shows a curious combination of the idea of Death striking at all strata of society, and Death striking as a punishment for evil as in the scene of the gambler with his gains still on the table. In the distance the death bells toll, fires have broken out and ships sink in a motionless sea. The barren landscape and sombre colouring enhance the desolation of the scene.

The detail shows the death cart, below which skeleton Deaths are attacking the King, the Mother and the Cardinal.

Plates 34 and 35 *The Dulle Griet* (Mad Meg) and detail. 1562. 45 ¼ × 63 ⅜ in. (116 × 161 cm.). Musée Meyer Van den Bergh, Antwerp.
In the foreground centre appears the large figure of Dulle Griet armed with kitchen utensils and a long poker who has penetrated to the very gates of Hell in what appears to be a plundering expedition. She is followed by a group of housewives fighting the devils and attacking the fortress of Hell. The rich fantasy shown by Bruegel in interpreting monstrous beings and hideous devils parallels the imaginative horrors of Jerome Bosch and was certainly one of the paintings that earned for him the attribute 'a greater Bosch'. It is not quite clear what the underlying meaning of the picture is. Grossmann sees in it the castigation of the sin of Covetousness. Mad Meg to gain her ends does not hesitate to attack the Devil himself in his own stronghold.
In the detail, the man described by Grossmann as 'The Tempter on the Roof' is sitting astride the roof of a house with a boat (the ship of fools?) on his back and shovelling money from a broken egg to the housewives in order to deflect them from their attack on the fortress of Hell.

Plate 36 *Head of an old Peasant Woman. c.* 1568. 8 ⅝ × 7 ⅛ in. (22 × 18 cm.). Pinakothek, Munich.
Although this small panel, probably a late work, is the only extant study of a portrait head by Bruegel that has come down to us, entries in old inventories do suggest that he did others. A profile head with half open mouth can be seen in various pictures such as *Dulle Griet*, in a more schematic treatment, and in the drawing of the connoisseur (frontispiece).

Plate 37 *The Adoration of the Kings.* 1564 43 ¾ × 32 ¾ in. (111 × 83.5 cm.). National Gallery, London.
Only two upright paintings by Bruegel are known today. The other, not illustrated, representing the Resurrection of Christ is a brush and pen drawing on paper attached to a panel and was certainly intended as a picture. The *Adoration* is also the first picture in which Bruegel uses only few very large figures and is one of the rare works in which landscape plays no part. It is also the most Italian in style and composition of all Bruegel's works.

Plate 38 *Wedding Dance in the Open Air.* 1566. 47 × 62 in. (119 × 157 cm.). Institute of Arts, Detroit.
Pictures of this kind earned for Bruegel his nickname of Peasant Bruegel. Formerly the subject matter was taken at its face value and pictures such as this and plates 39 and 40, were regarded merely as masterly interpretations of peasant festivities observed with a keen eye for the awkward shapes and clumsy movements of the 'capering' peasants – which

indeed they are. Modern observers see a deeper meaning in the scenes. In none of the surviving wedding pictures is there any hint of awareness of the sacred nature of the wedding sacrament. The emphasis is concentrated on feasting, dancing and revelry. So suggestive is Bruegel's interpretation of the gathering momentum of the revelry that we can well believe that in a short time this as yet good-humoured spirit will end in strife and debauchery.

Plate 39 *Peasant Wedding c.* 1567. 44⅞ × 64⅛ in. (114 × 163 cm.). Kunsthistorisches Museum, Vienna.
A lost strip at the bottom, which has been replaced by a later addition, may have contained the signature and date. In 1659 the picture was listed in the inventory of Archduke Leopold Wilhelm. The guests are seated round the long diagonally placed table with the bride clearly visible against the backcloth above her and wearing the bridal crown. Her pious attitude with folded hands and immobile features seems modelled on earlier interpretations of the bride in the Marriage at Cana. It is not so easy to pick out the bridegroom and various people have been suggested. One possible candidate is the man on the extreme left pouring out the wine, another is the man at the head of the table leaning back to pick up a pancake from the tray held by two men. The tray is a wooden door, probably the unhinged door of the entrance seen in the background left through which the crowds are pouring in from outside. It has recently been suggested that the man in front holding the improvised tray and seen from the back is the bridegroom. The wooden spoon stuck in his hat is said to be always worn by the groom at his wedding as a sign of hospitality and plenty. Grossmann on the other hand points to the old symbolism of the wooden spoon as a sign of gluttony.

Plate 40 *Peasant Dance. c.* 1567. 44⅞ × 64⅝ in. (114 × 164 cm.). Kunsthistorisches Museum, Vienna.
The latest and finest of the surviving large-scale figure scenes of peasant festivities. Like the others it is probably not meant simply as a genre scene but has a moral lesson. The revelry has reached a dangerous stage, for a quarrel has already broken out among the peasants seated at the table on the left hand side. But we are swept into the dynamic rhythm of the dance by the couple swinging in from the right. See Introduction page 22. The picture was the prototype for countless scenes of peasant revelry in later Dutch and Flemish paintings. Individual motifs such as the kissing couple behind the table were used by Jan Steen and other artists until far into the 17th century.

Plates 41 and 42 *The Land of Cockaigne* and detail. 1567. 20½ × 30¾ in. (52 × 78 cm). Pinakothek, Munich.
The picture was first mentioned in an inventory of the Imperial collection in Prague. Three men, apparently asleep or dreaming lie in a strange surrealist landscape in which food is available on all sides, practically begging to be eaten. For all its whimsical humour the picture is almost certainly intended as an attack on gluttony, as Grossmann has suggested. See Introduction page 23.

Plate 43 *The Corn Harvest.* Detail from plate 13.

Plates 44, 45 and 46 *The Parable of the Blind* and details. 1568. Tempera on canvas. 33⅞ × 60⅝ in. (86 × 154 cm.). Museo Nazionale, Naples.
The parable referred to is in St. Matthew XV, 14: 'If the Blind lead the Blind, both shall fall into the ditch'. The tragic mood of the picture is, as so often in Bruegel's work, enhanced by the general colour scheme which is attuned to an overall browny mauve accord with a faint greyness in all the tones. The composition of the picture is masterly; the ragged line of stumbling men creates mounting tension as we move down from the last blind man, as yet barely aware of impending disaster, through the growing sense of uneasiness in the faces and figures of the next three men to the inevitable climax of the fall. In addition to the physical deformity, which is presented with appalling naturalism the fearful tragedy of blindness itself is revealed. Their handicap has isolated these men from their fellow creatures and they seem cut off from all human contact as they grope their way through the landscape. Grossmann sees in the work the deeper meaning of inner blindness to the Christian faith as symbolised in the church. This picture represents Bruegel's last and greatest interpretation of a subject that must have preoccupied him for many years. As early as 1559 in the *Fight*

between Carnival and Lent a blind man can be seen amidst the group of beggars on the Lent side.

Plate 47 *The Cripples.* 1568. 7⅛ × 8½ in. (18 × 21.5 cm.). Musée du Louvre, Paris.

This small panel has always been known as *The Cripples* but it has recently been shown that the men are, in fact, lepers. The fox tails prominently displayed on the front and back of their tunics were worn at the lepers' processions on the Monday after Twelfth Night and during the carnival season. The fact that they also wear carnival hats would seem to confirm this theory. The solid stone walls of the buildings on either side behind the group have a prison-like quality and may indeed represent the asylum in which they are isolated. The largest of the five men appears to be gazing out at the open country through the archway. The two men facing us with half open mouths seem to be shouting aggressively and all are filled with a kind of animal vitality which makes their condition all the more painful.

Plate 48 *The Misanthrope.* 1568. 33⅞ × 33½ in. (86 × 85 cm.). Museo Nazionale, Naples.

The translation of the inscription at the bottom reads: 'Because the world is so faithless I am going into mourning'. Little more than the nose and tight lipped mouth of the old man covered by a long dark cloak and hood is visible. He walks with folded hands across the landscape unaware of the bent little figure in the glass ball, symbolising the Faithless World busily engaged in stealing his purse.

Plates 49 and 50 *The Peasant and the Birdnester* and detail. 1568. 23¼ × 26¾ in. (59 × 68 cm.). Kunsthistorisches Museum, Vienna.

Hulin de Loo identified the subject as the illustration of a Flemish proverb: 'He who knows where the nest is, has the knowledge, he who robs it has the nest' and this has been widely accepted. The boy has already climbed up the tree and is taking the bird from the nest. In the foreground centre a powerful Michelangelesque figure of a peasant is striding towards the spectator and with tight pressed lips, but no further comment, points to the scene as he passes. The scene is set in one of Bruegel's most attractive landscapes painted in very thin colours, in parts barely concealing the ground, and giving an effect of vibrant light. Bostrom, drawing on contemporary sources, has shown that iris and blackberry symbolised a man strengthened by persecution and overcoming temptation and refer to the peasant. The dead willow stump symbolised useless people and refers to the thief.

Plate 51 *Storm at Sea.* 1568? 27⅝ × 38¼ in. (70.3 × 97 cm.). Kunsthistorisches Museum, Vienna.

The picture is unfinished and in very poor condition. Doubts have been raised as to its authenticity but the general view is that the work is by Bruegel. The subject illustrates a passage in Zedler's Universal-Lexicon: 'If the whale plays with the barrel that has been thrown to him and gives the ship time to escape, then he represents the man who misses true good for the sake of futile trifles'. The barrel can be seen in the water between the ship and the whale. On the far horizon silhouetted against a clearing in the sky a church with tall spire is visible which has been interpreted as the 'saving element in the dangers of life symbolised by the stormy sea'.

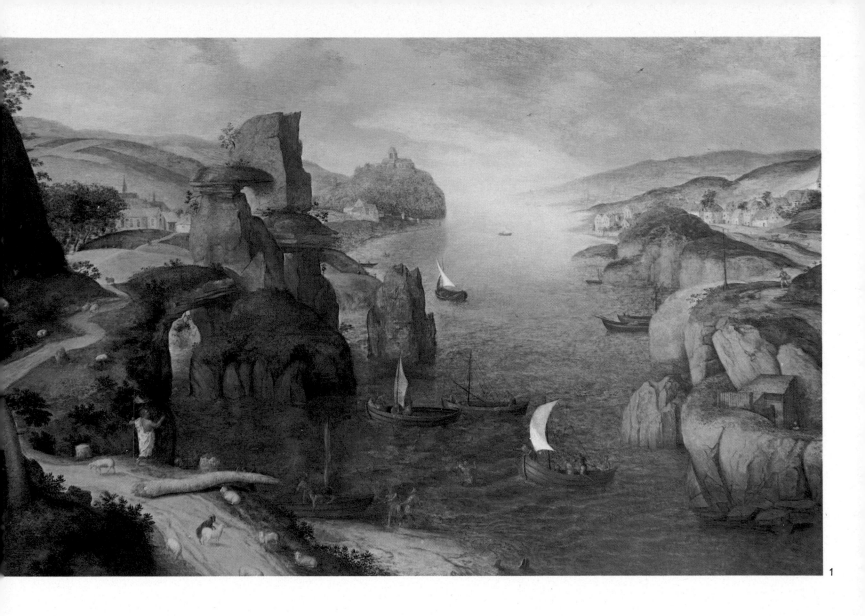

1

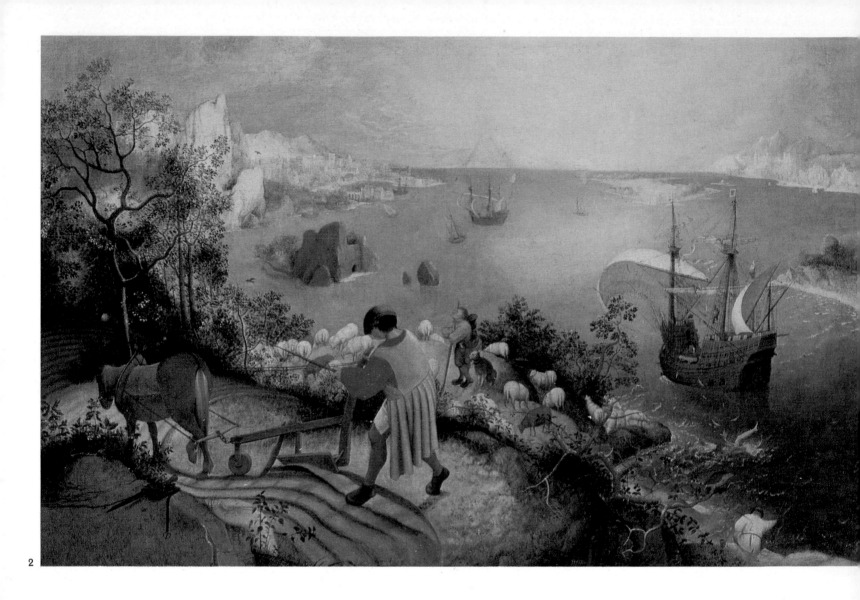

2

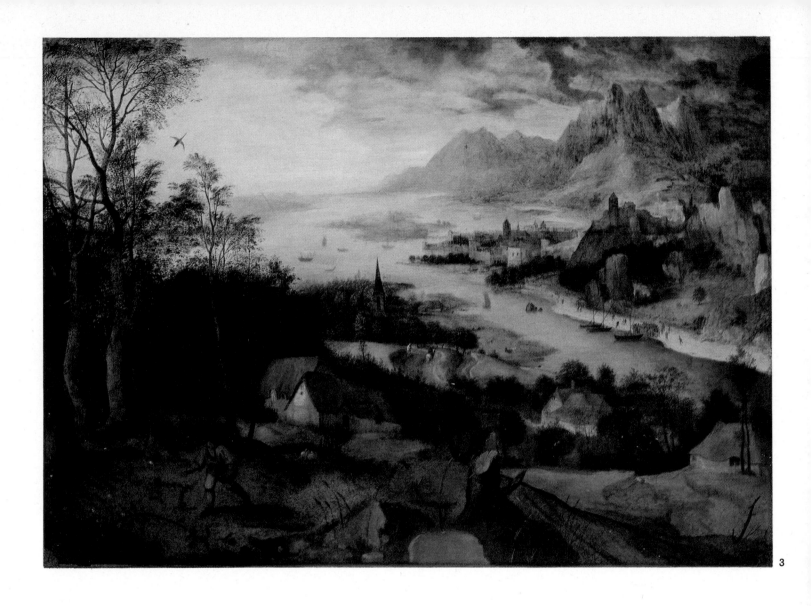

3

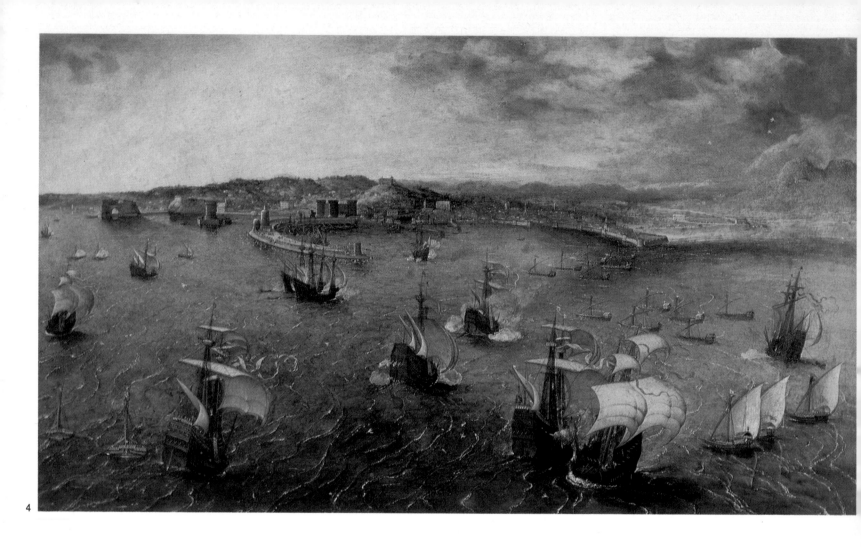

4

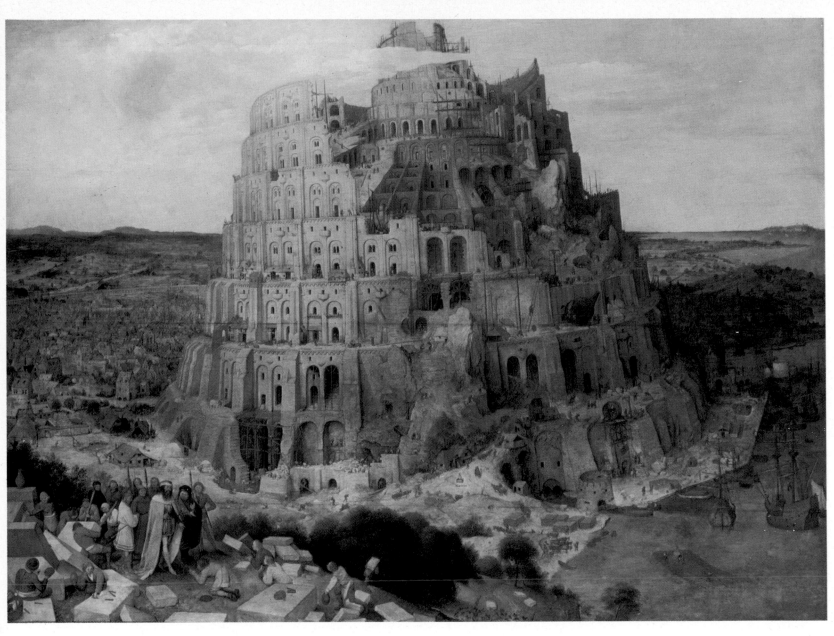

5

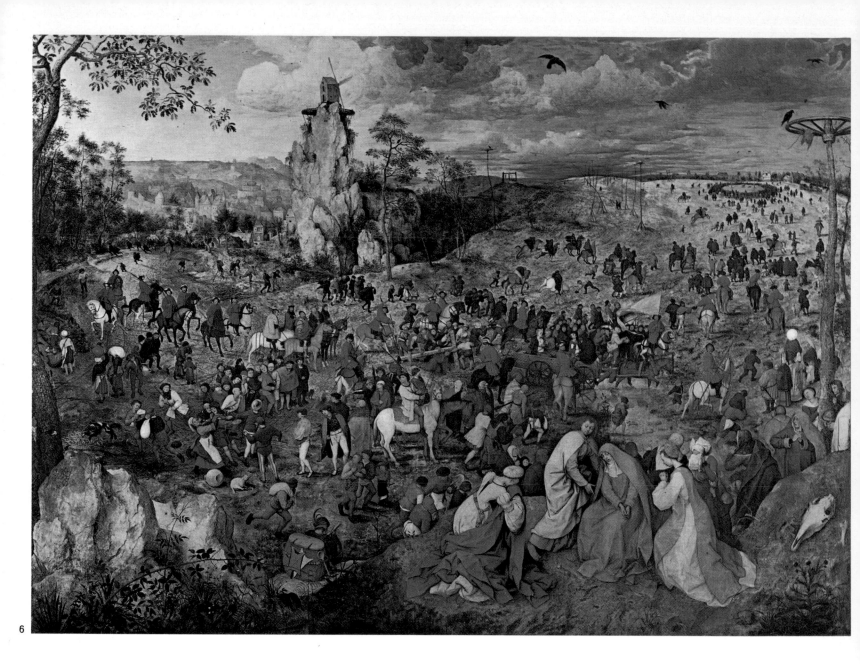

6

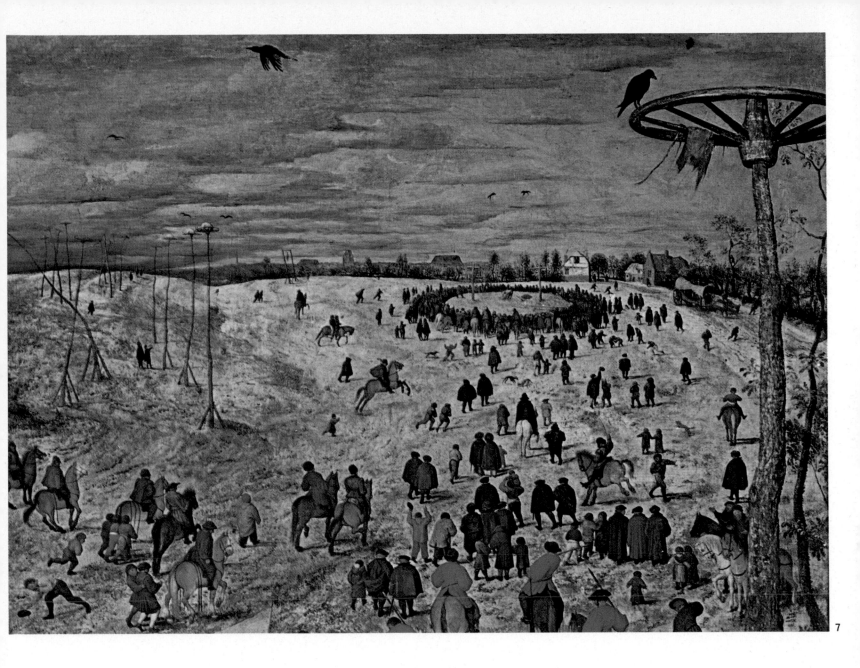

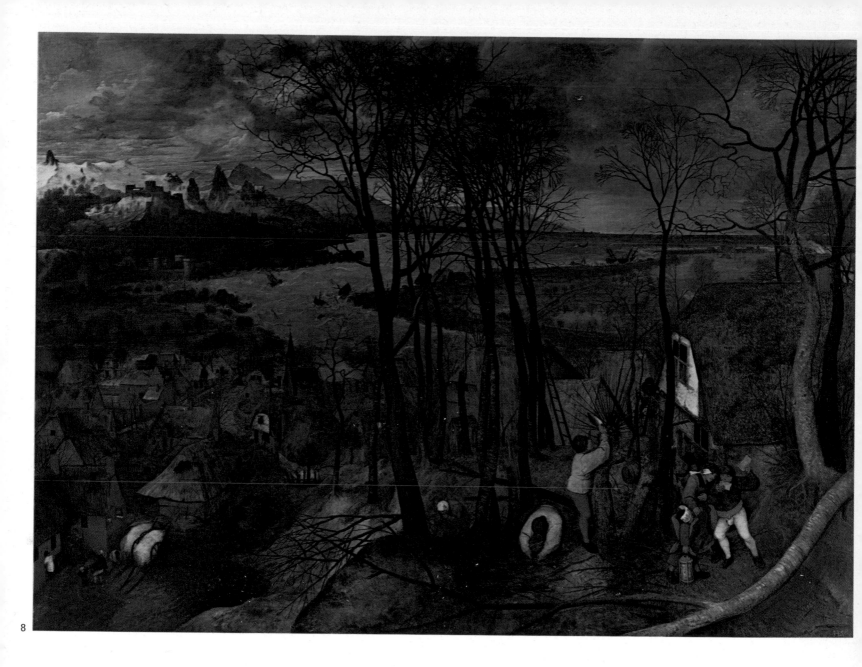

8

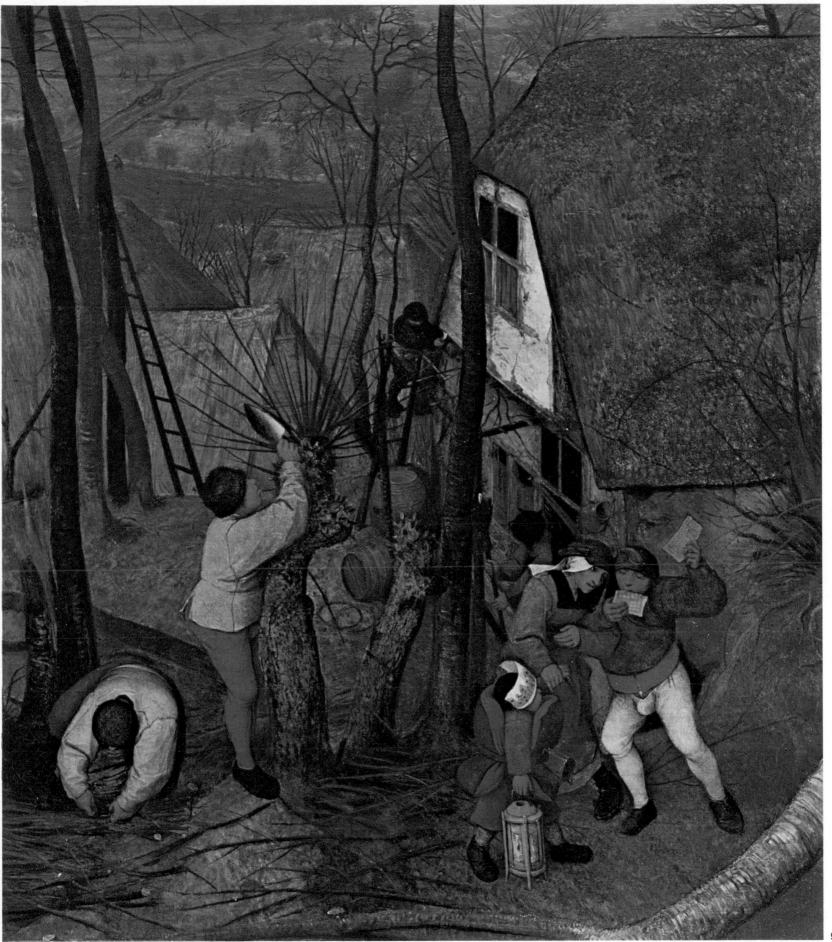

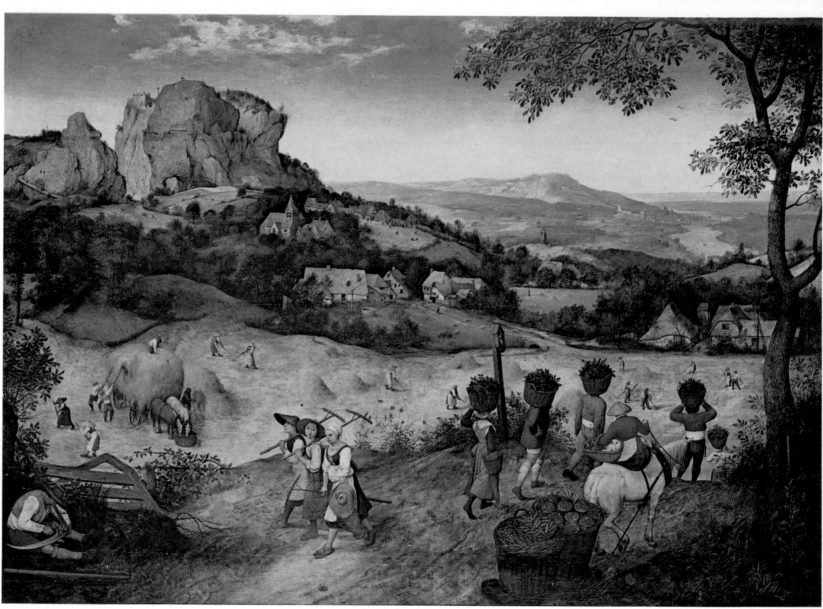

10

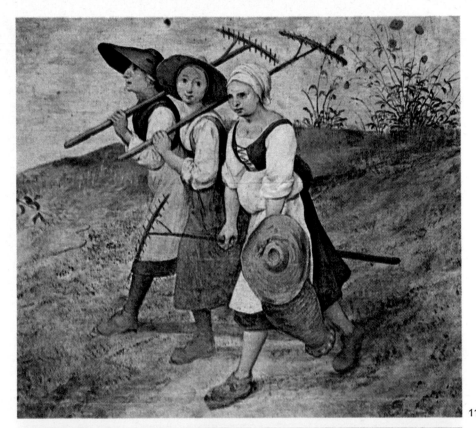

11

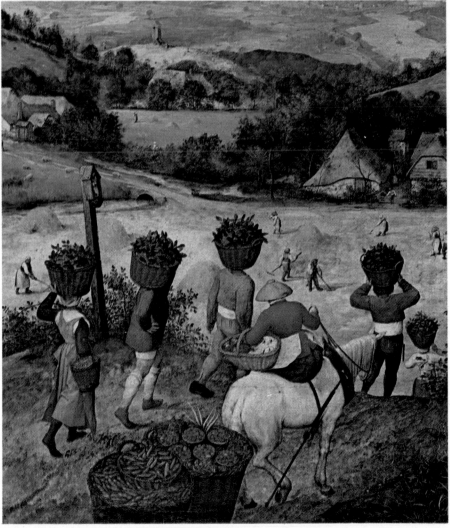

12

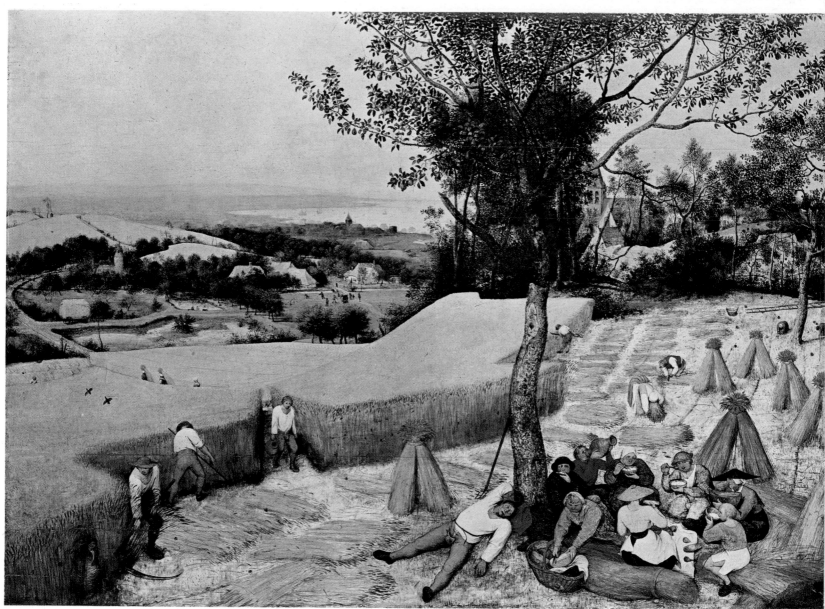

13

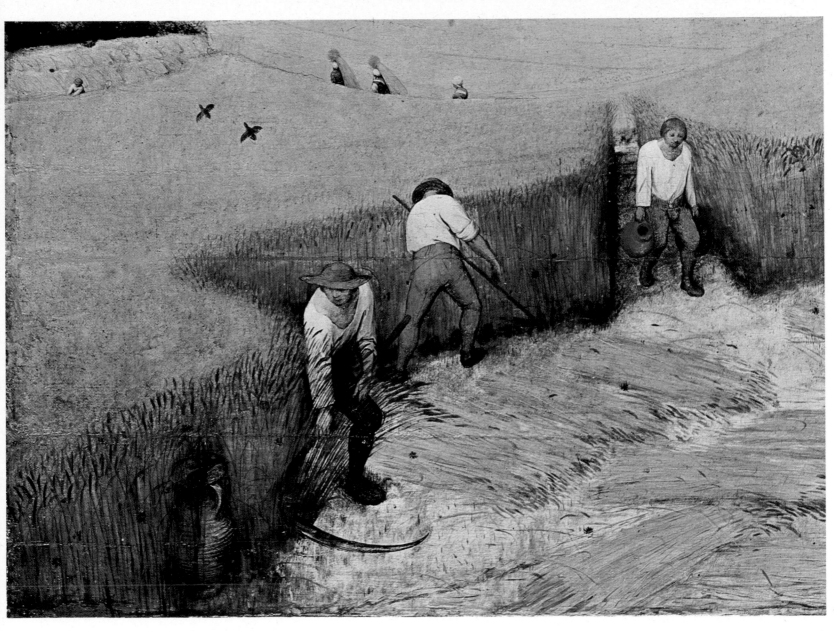

14

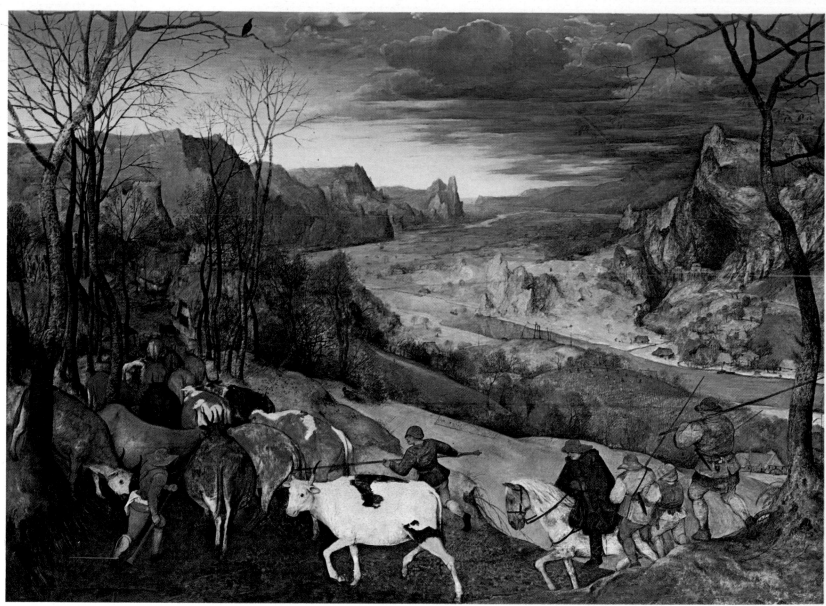

15

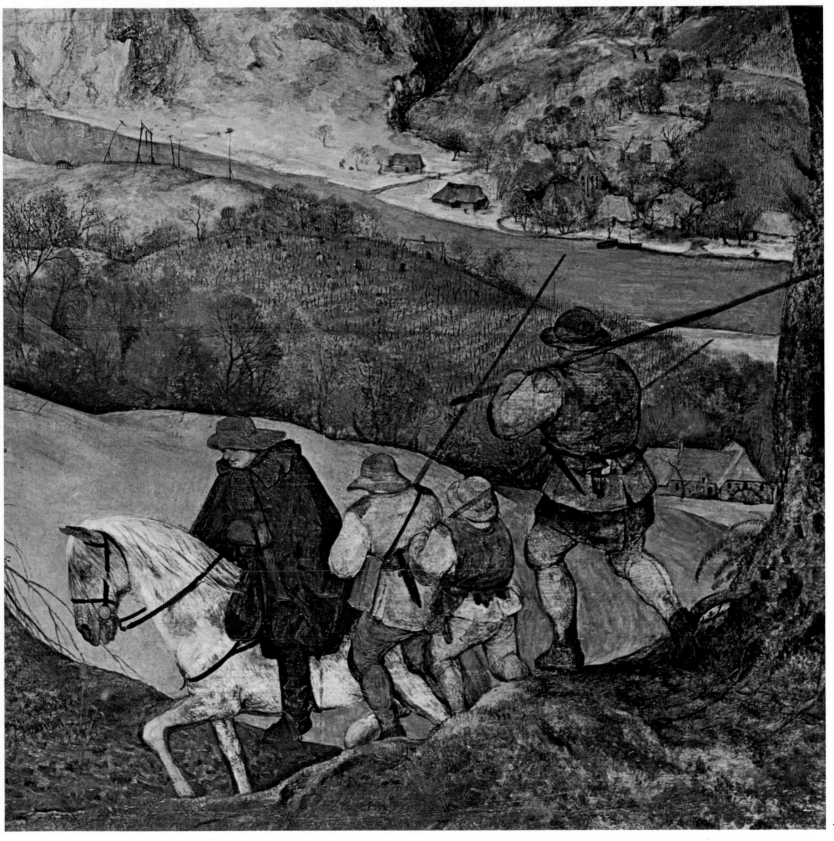

16

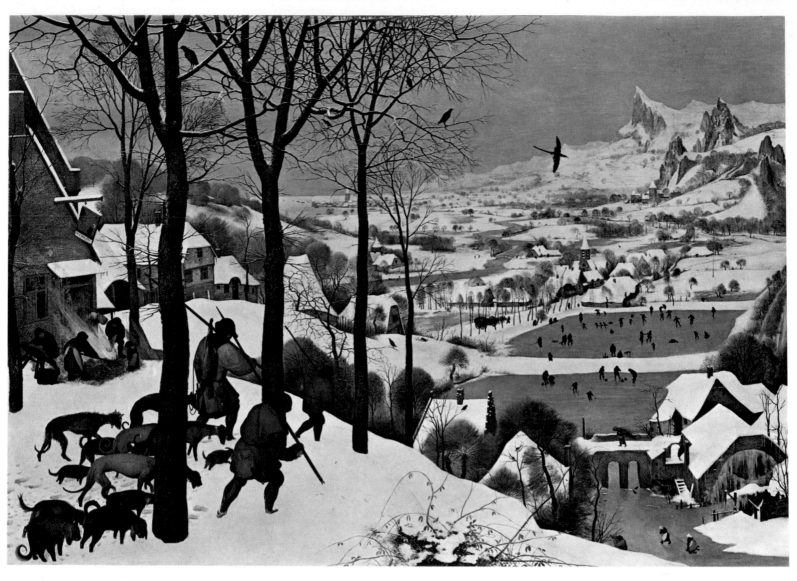

17

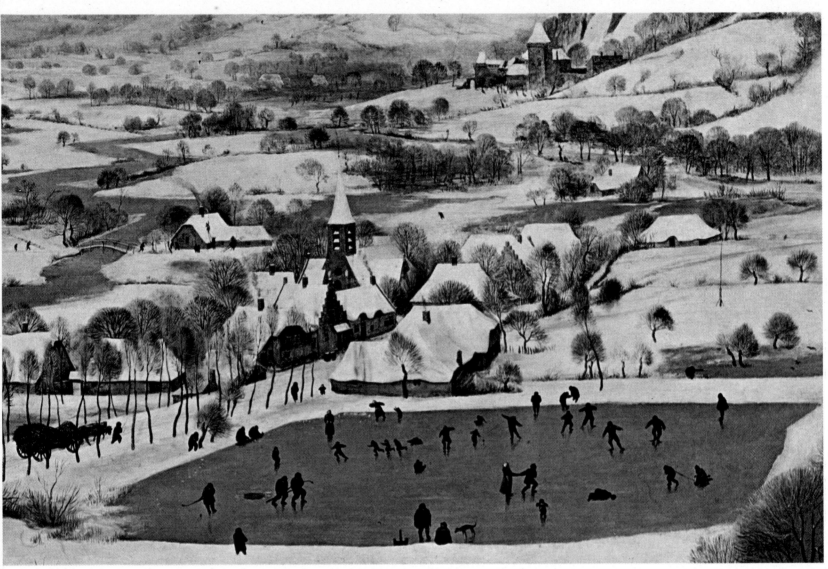

18

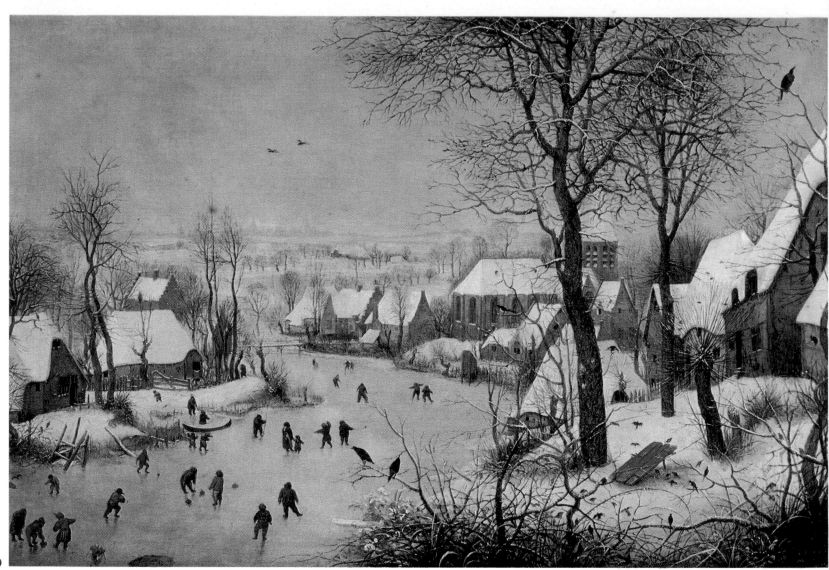

19

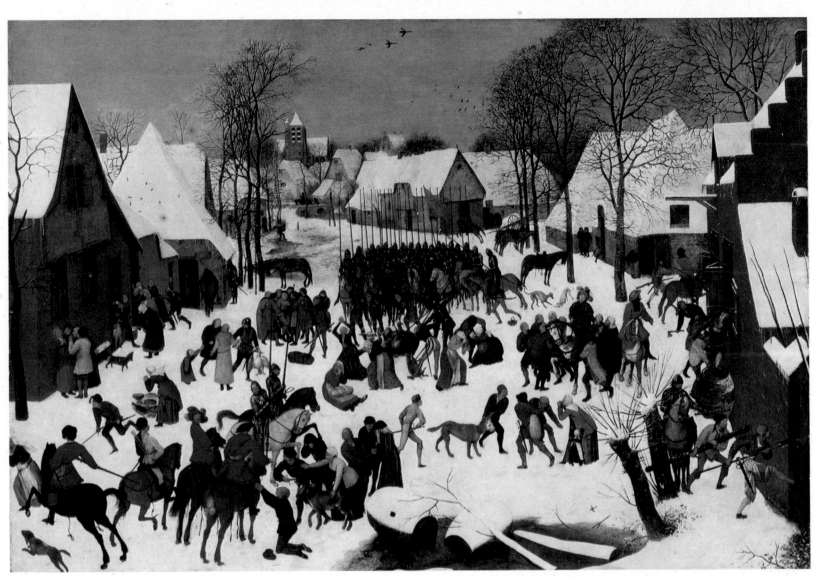

20

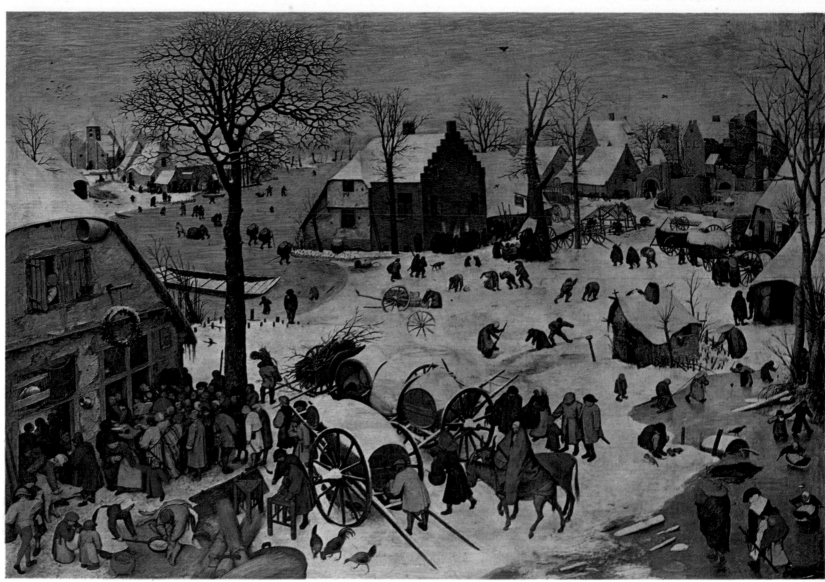

21

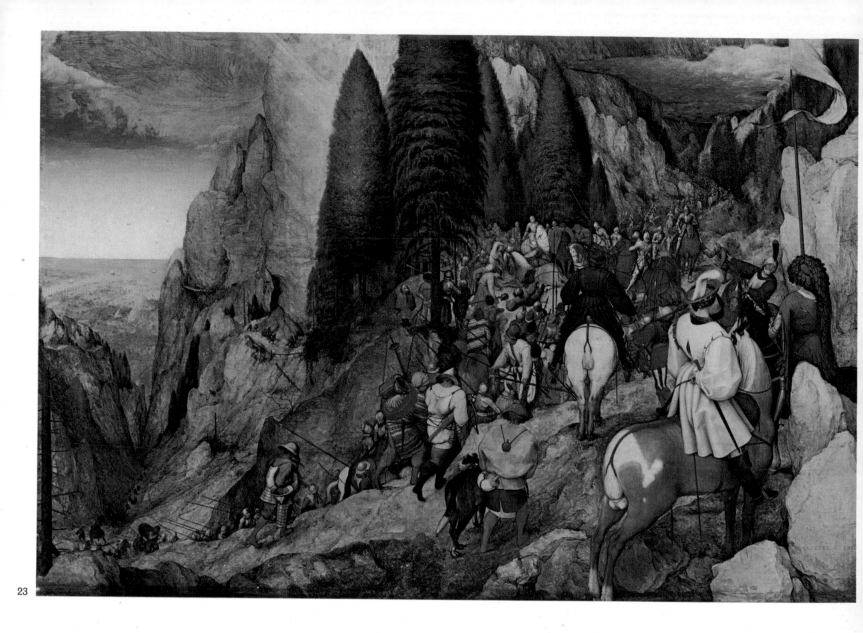

23

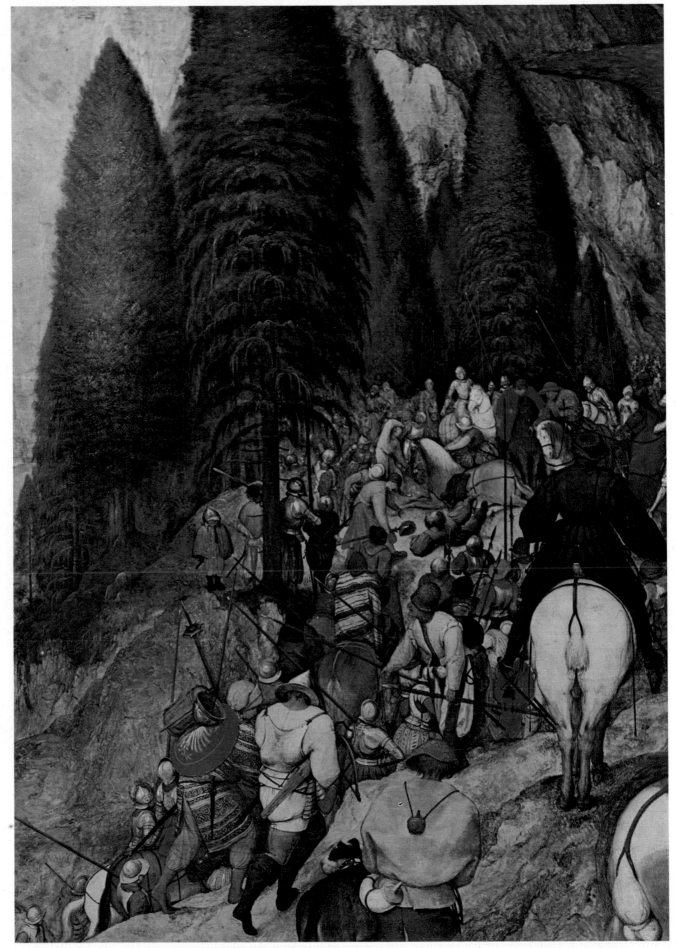

24

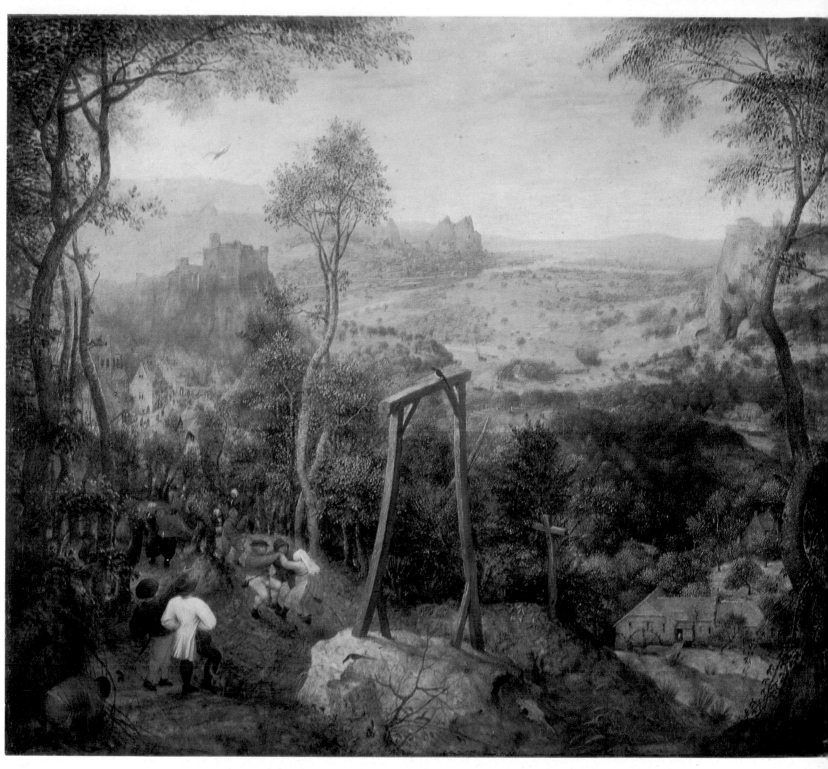

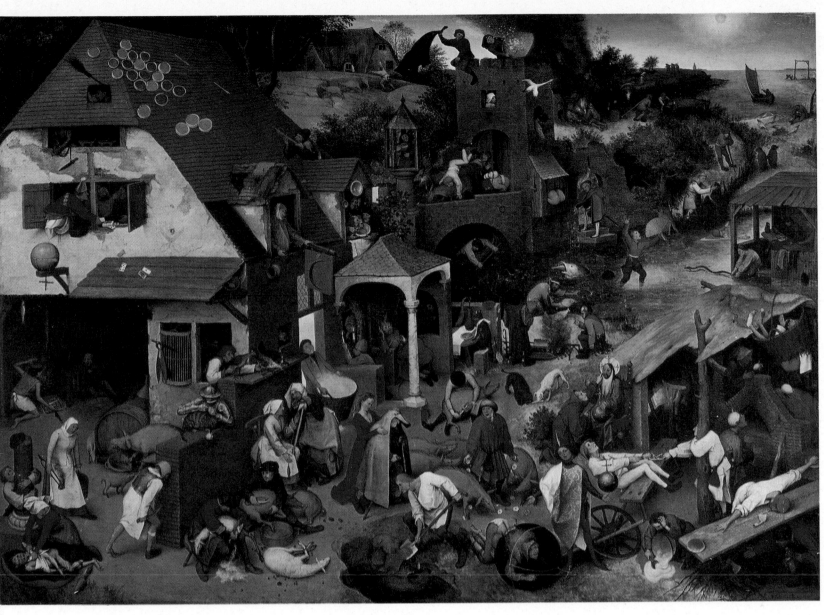

26

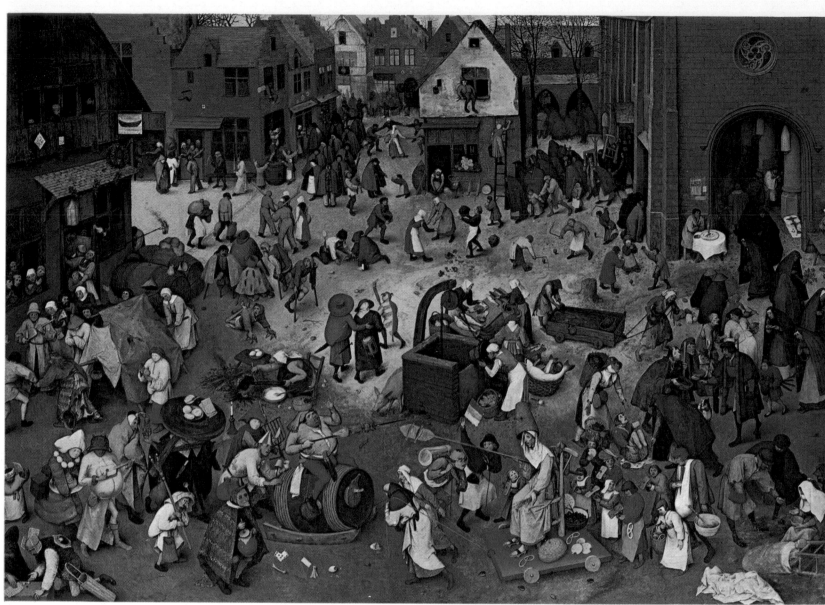

27

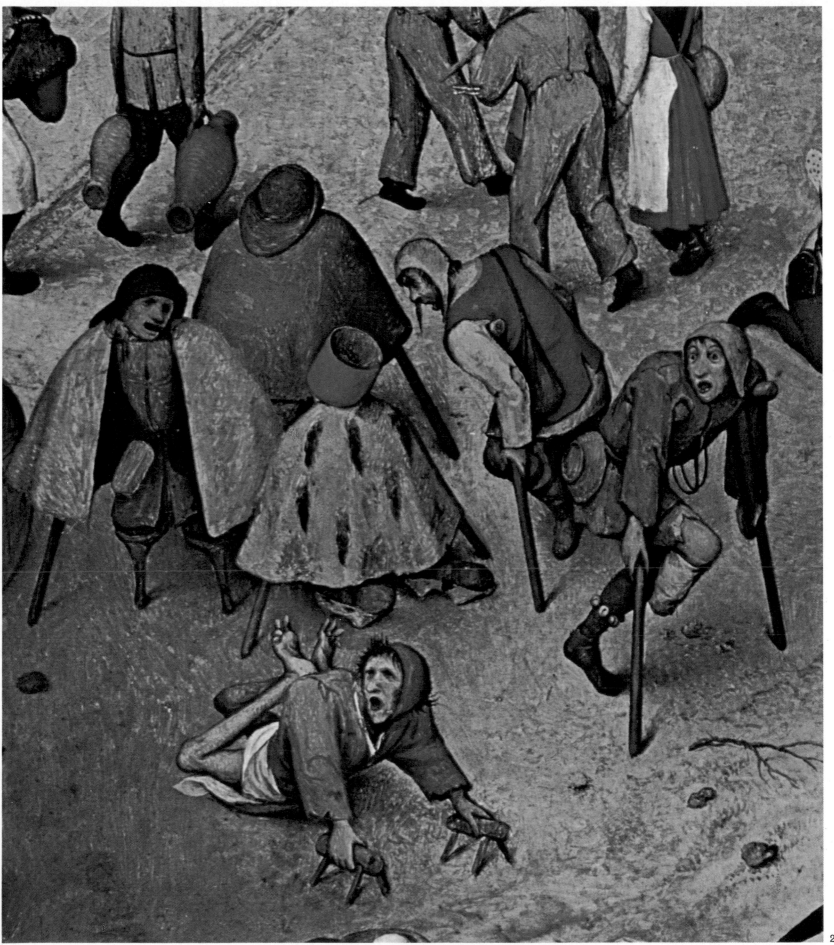

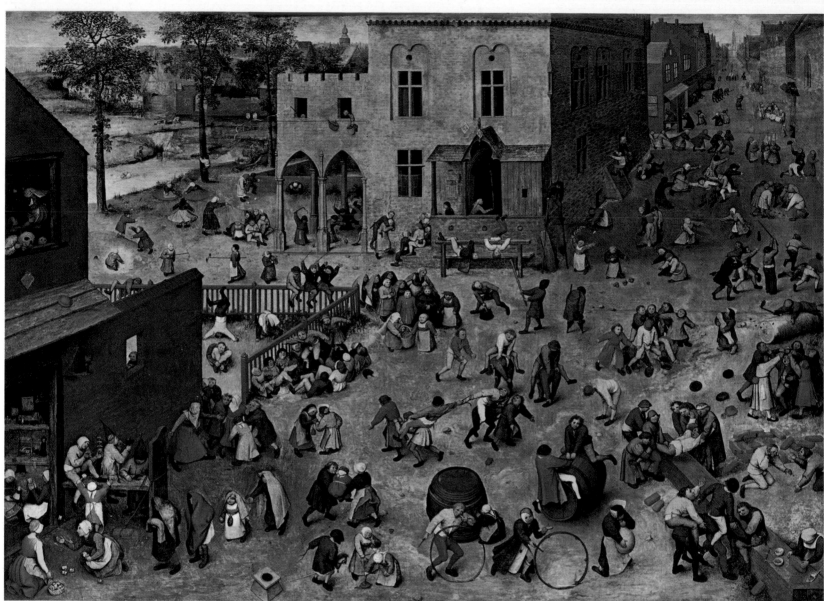

29

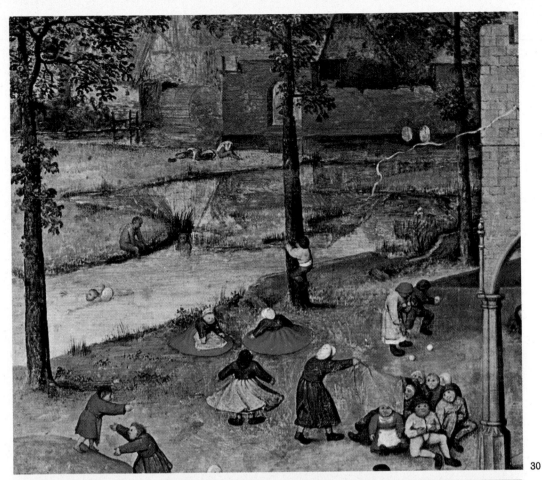

30

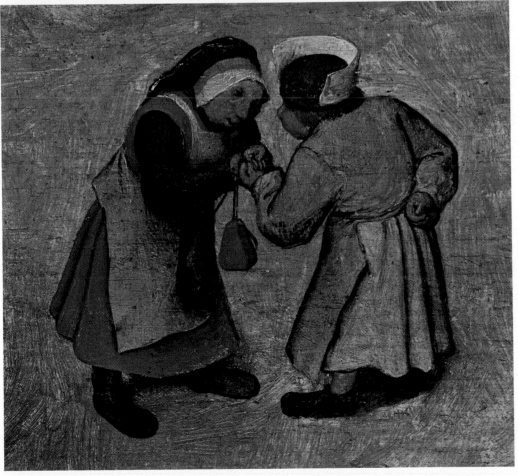

31

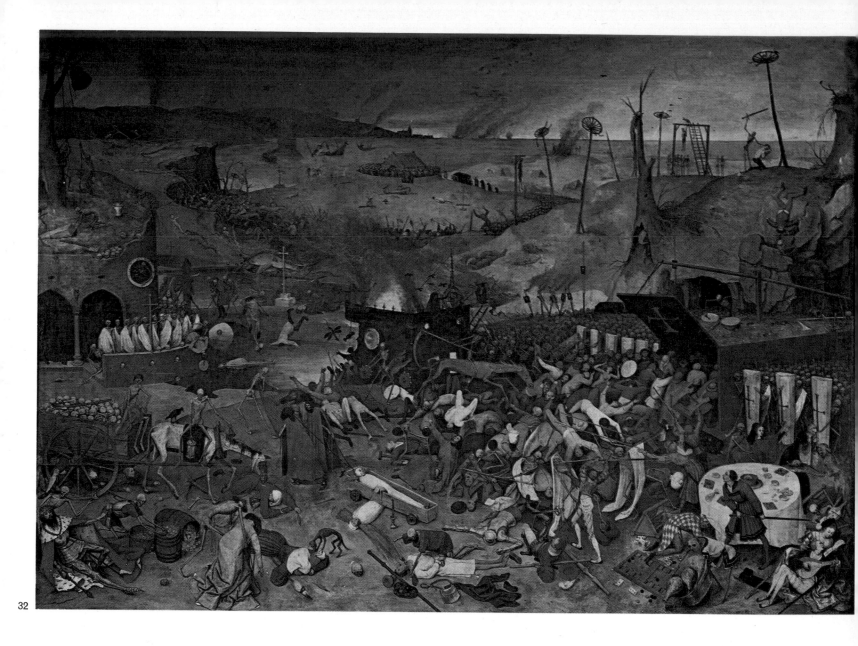

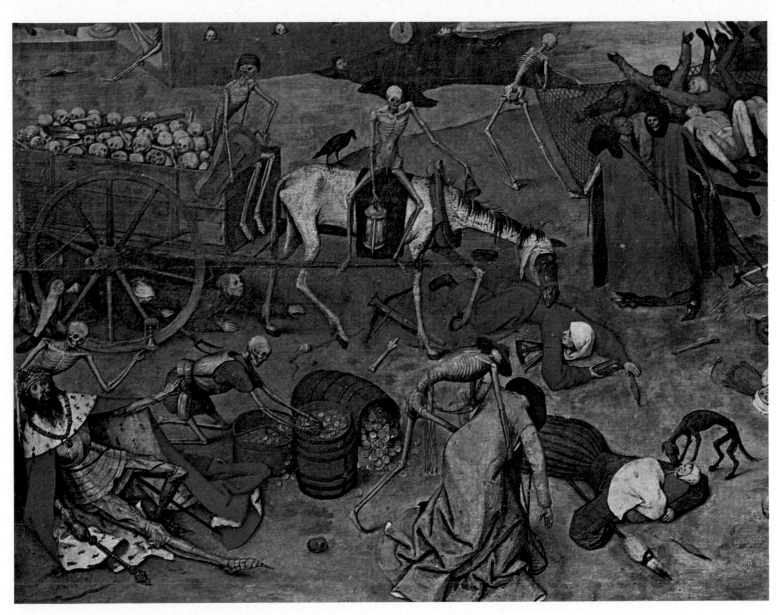

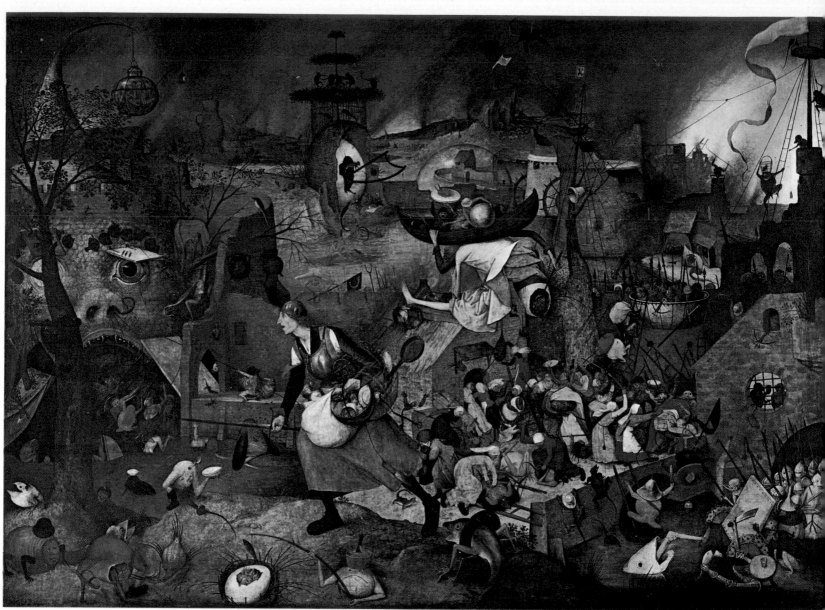

34

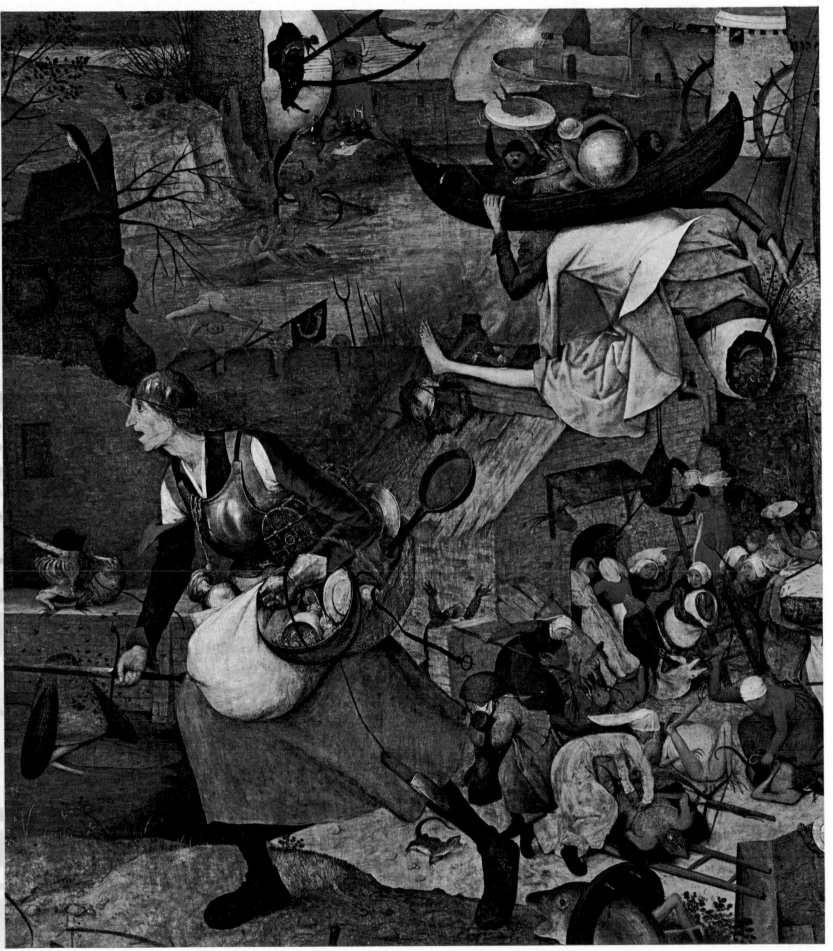

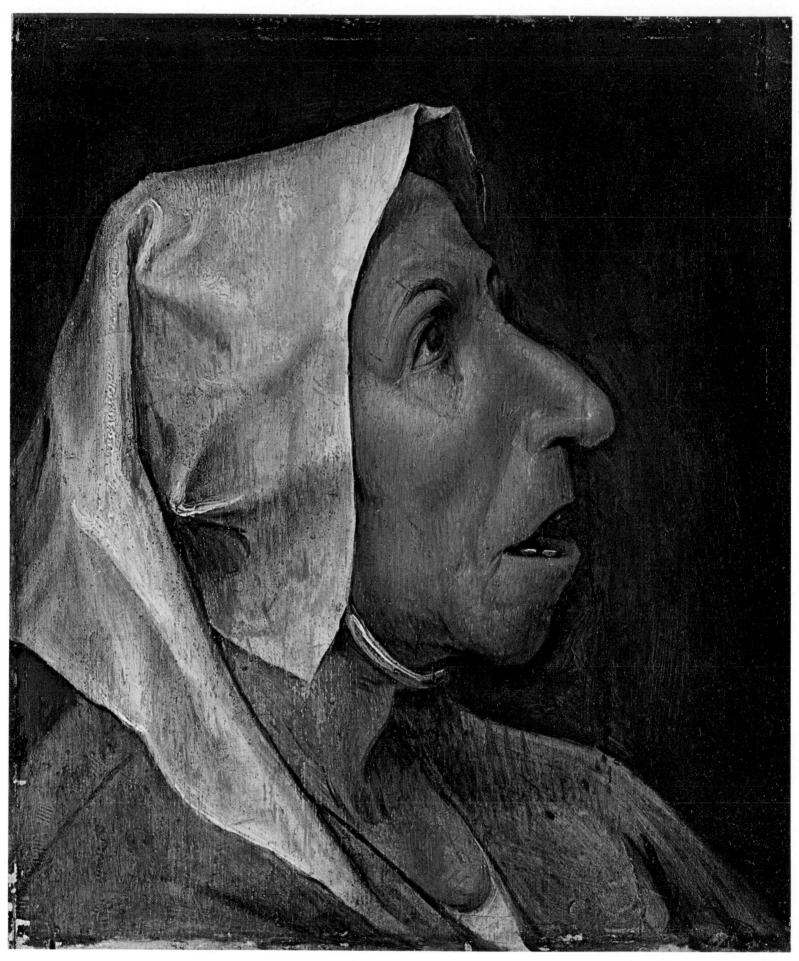

36

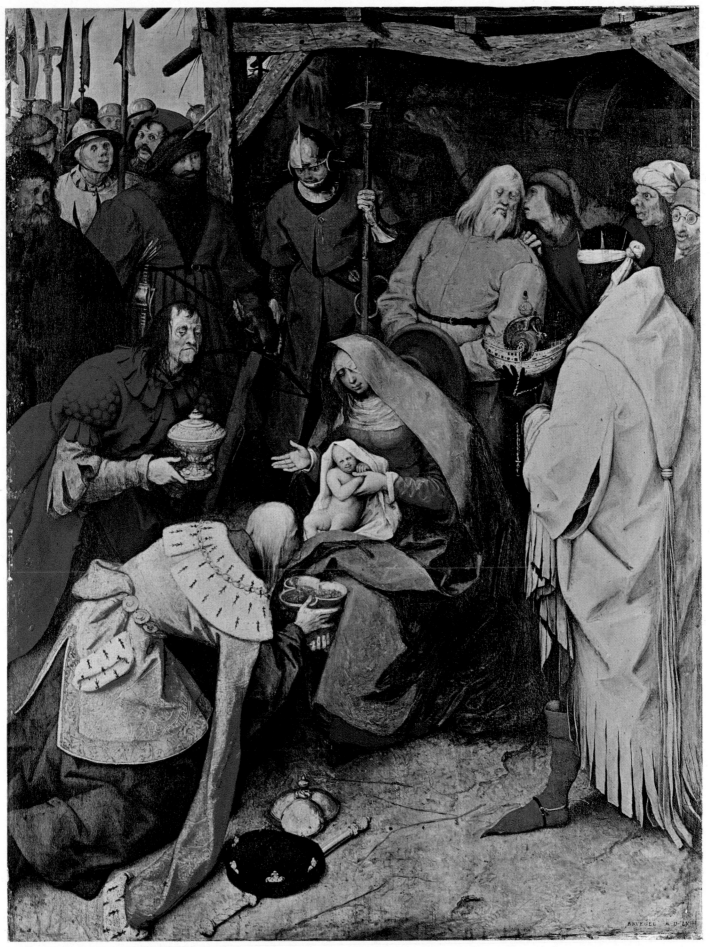

37

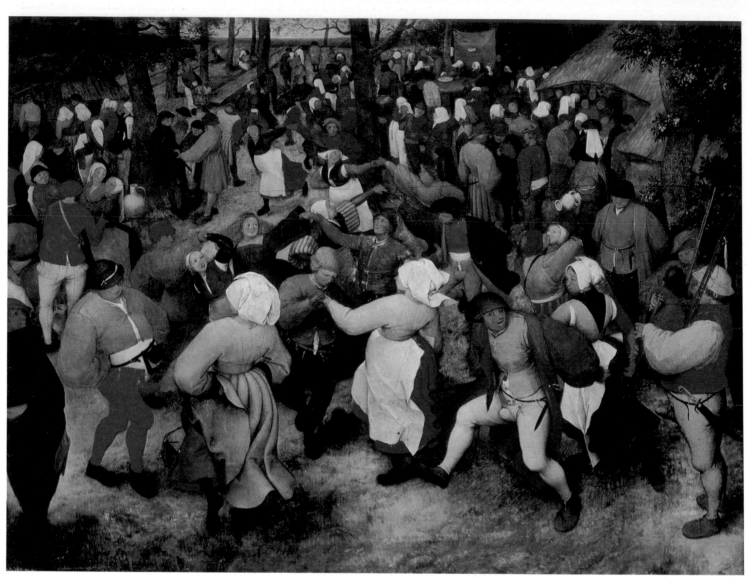

38

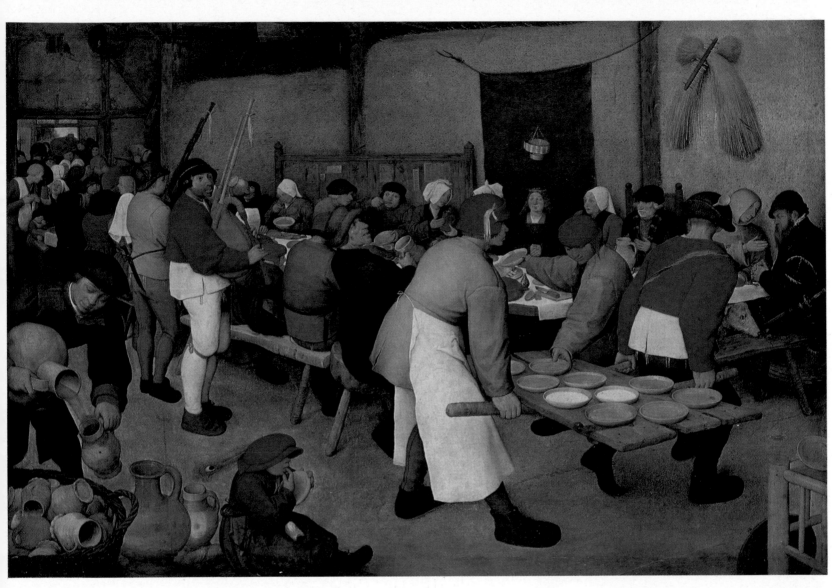

39

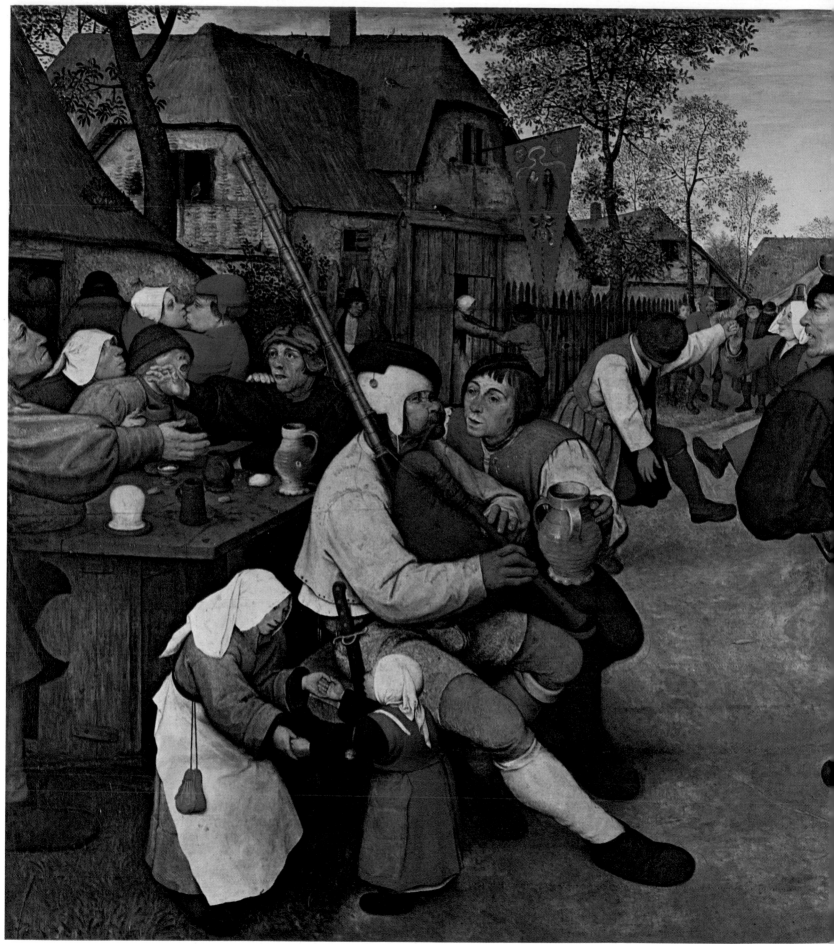

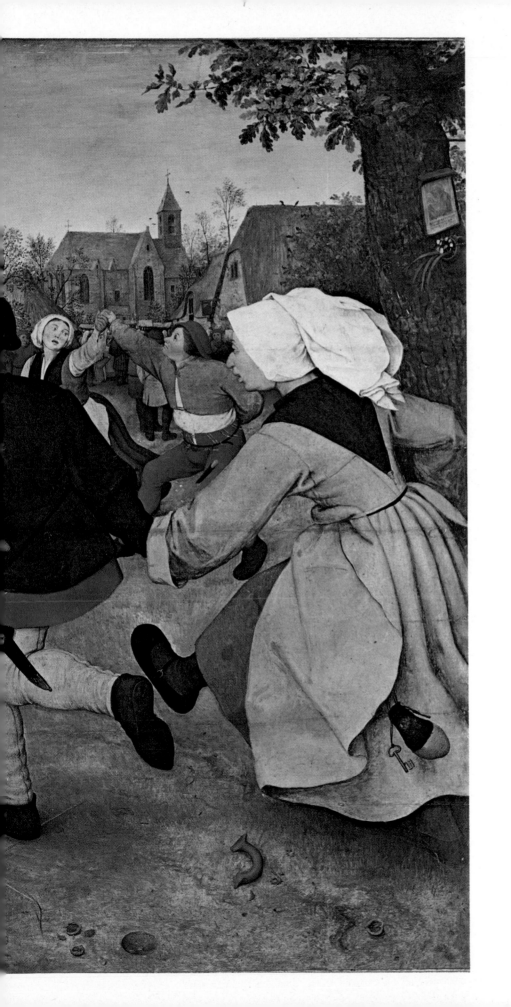

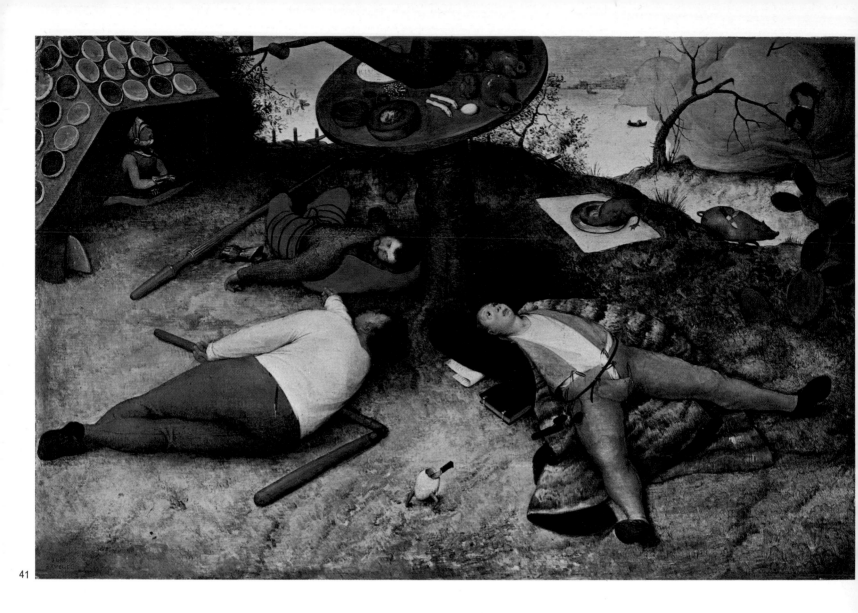

41

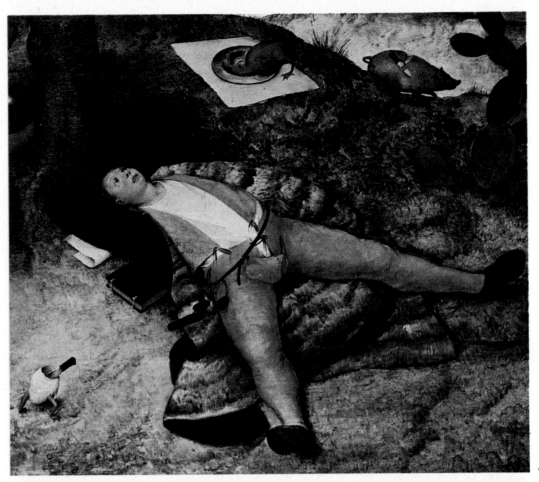

42

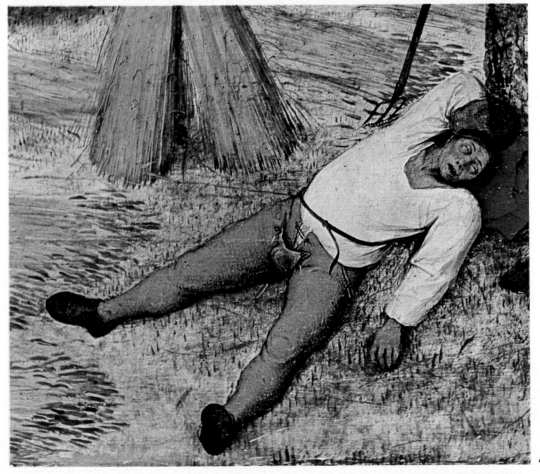

43

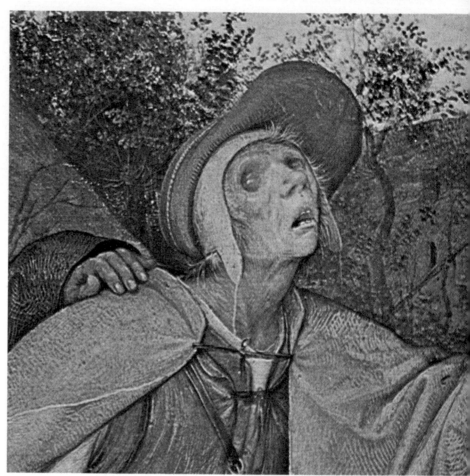

45

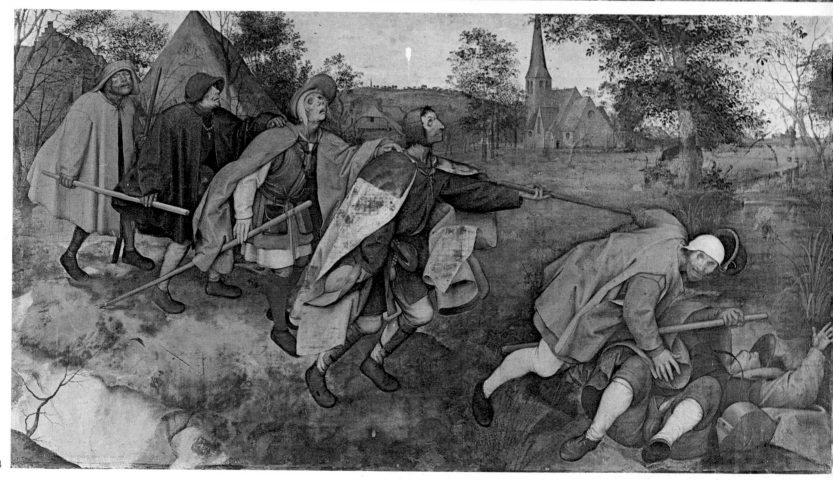

44

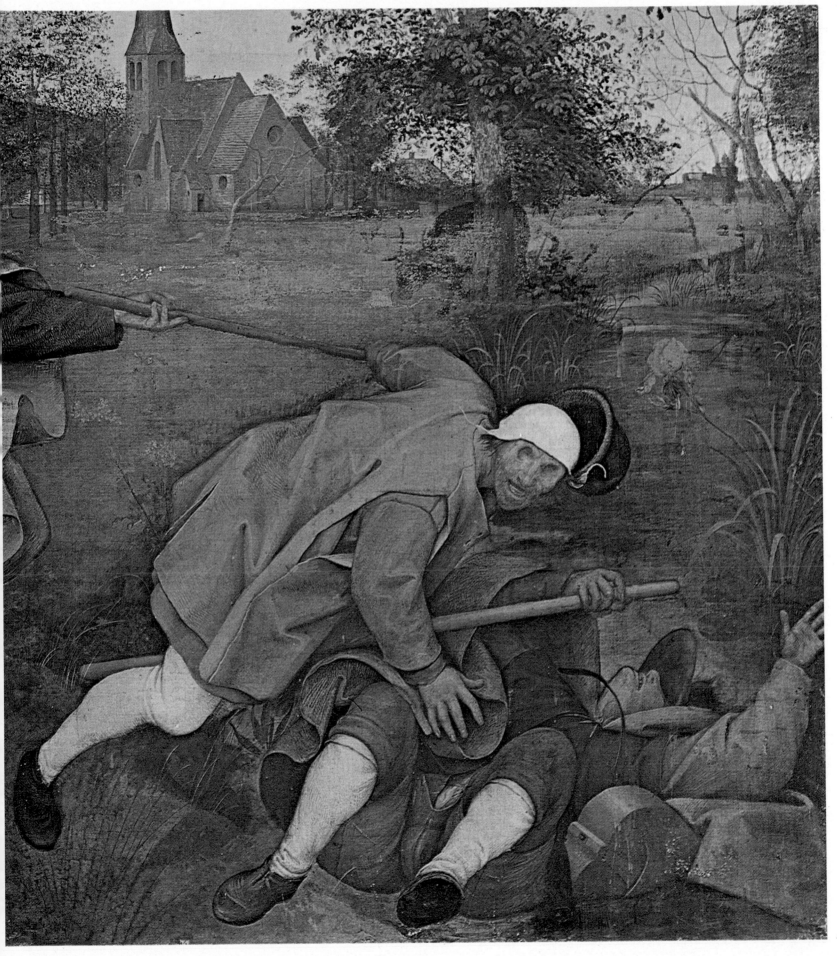

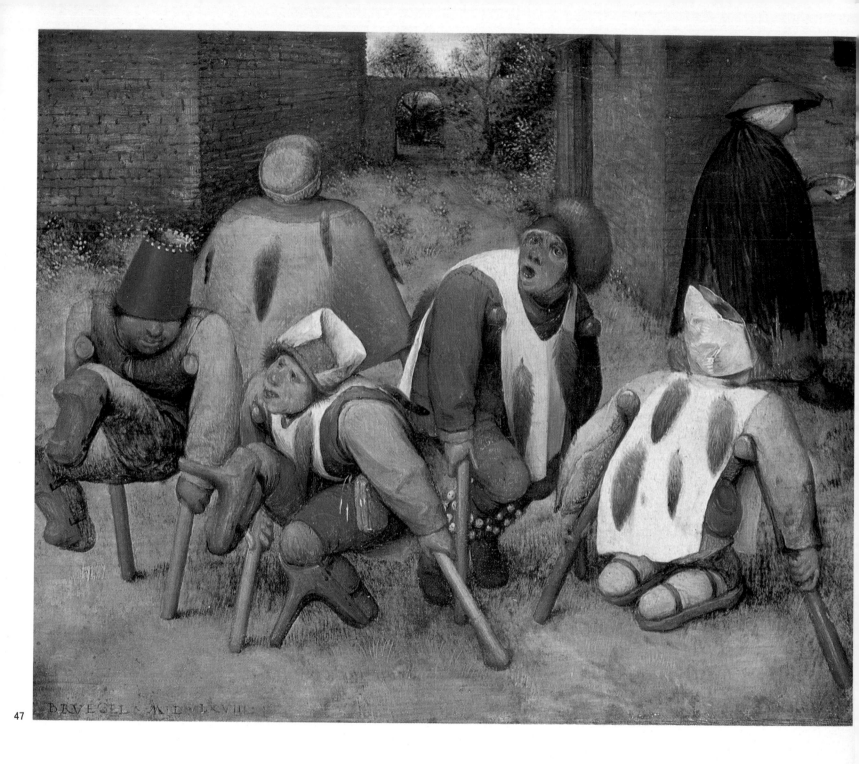

47

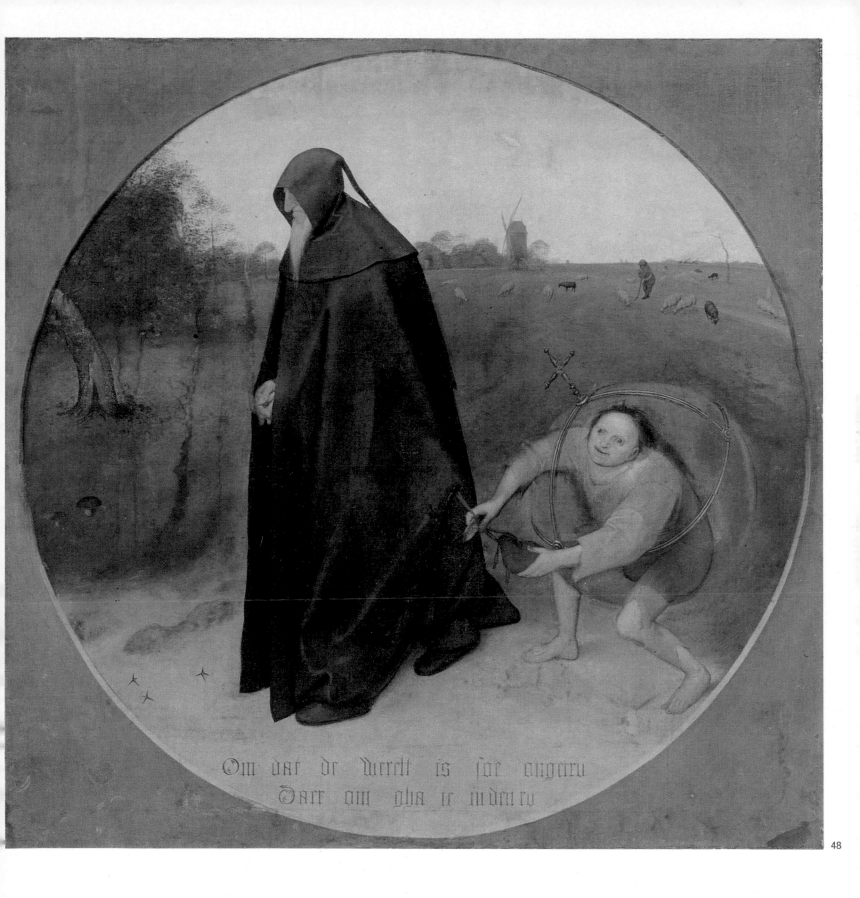

Om dat de Werelt is soe ongetru
Daer om gha ic in den ru

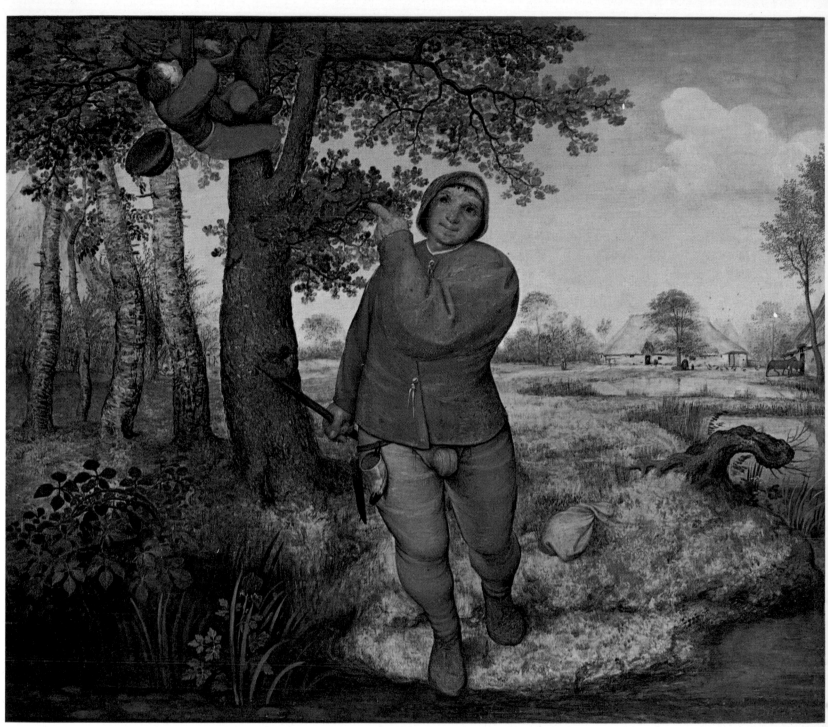

49

50

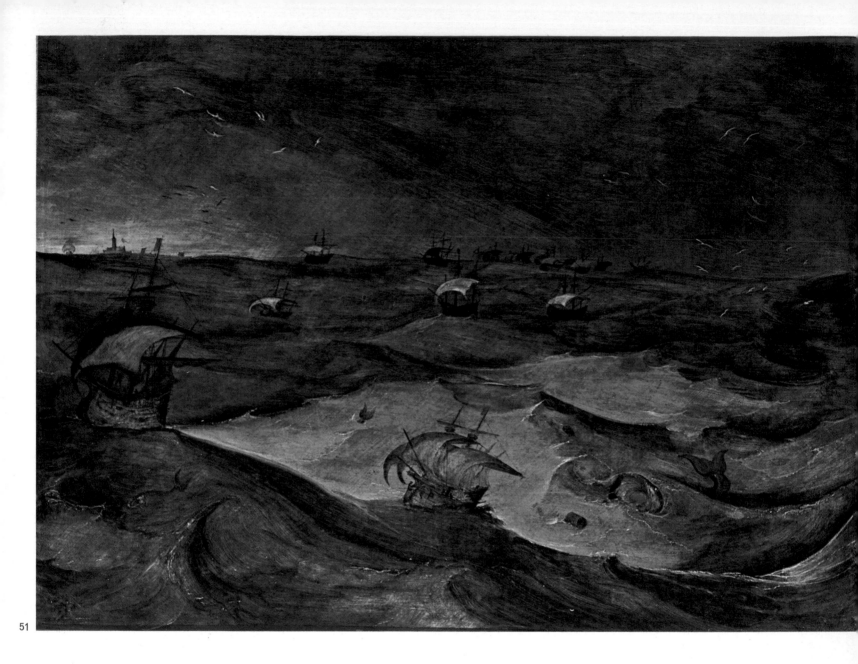

51